pretty
little
london

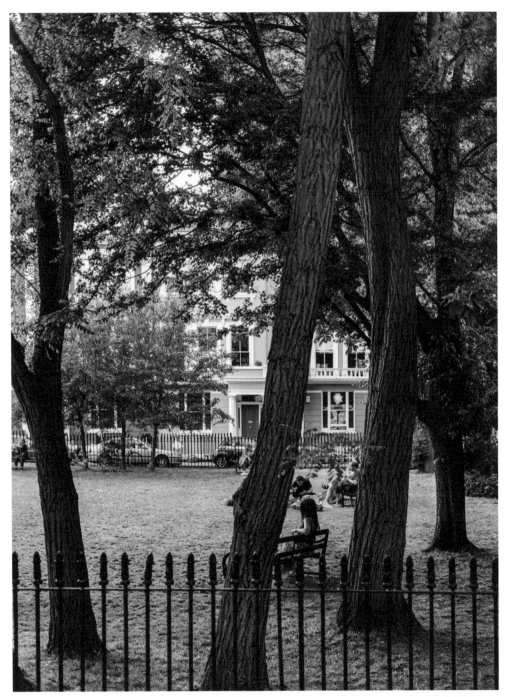

Primrose Hill

pretty Little london

A SEASONAL GUIDE TO THE CITY'S
MOST INSTAGRAMMABLE PLACES

SARA SANTINI & ANDREA DI FILIPPO

FRANCES
LINCOLN

Contents

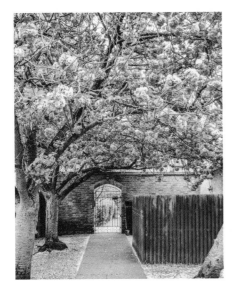

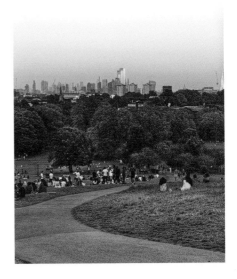

Spring

Summer

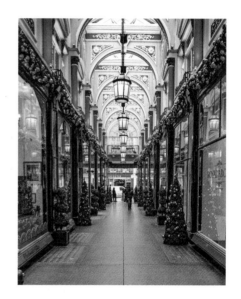

Autumn

Winter

 Food Drink Parks Walking Shopping Museums/Galleries

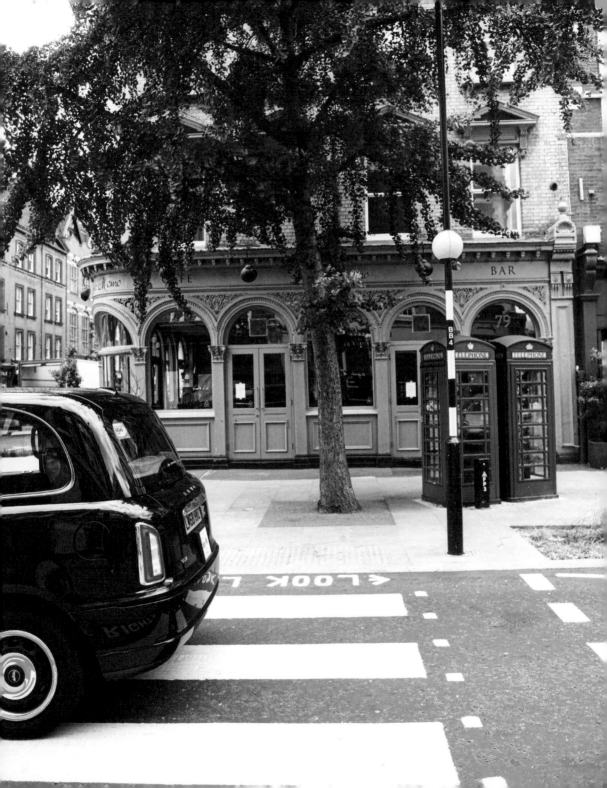

Introduction

It's happened. It's actually happened. We have written a book. How is that even possible? Sometimes we still can't believe how quickly things have moved since the day we decided to start our Instagram account and blog, *Pretty Little London*. It all started as a hobby, as a way to get creative in a city that sometimes sucks all the energy out of you and makes you wonder what you are really doing here – if you are chasing a dream that will never come true or if there actually is something here for you. The day we started this community, which has now become our life, we knew we had found what we had been looking for. It was an incentive for us to get creative, get out of our comfort zone and explore more of the city we lived in, which we found out we knew very little about, even though we had been in London for over a year. So how did it all start? Here is *Pretty Little London*'s story.

Marylebone Village

ANDREA and SARA moved to London from Italy in August 2014. Andrea is originally from Capaccio Paestum, a little town around an hour's drive from the Amalfi Coast in southern Italy, while Sara is from La Spezia, near the Insta-famous Cinque Terre in the north. Andrea had come to England for his master's degree in medical and institutional translation, while Sara was ready to start her bachelor's degree in fashion marketing and business management.

How did they meet? They were housemates (what a cliché, right?) in a place they both shouldn't have even been in – the Italian agency that set up their accommodation messed everything up, sending Andrea to Wood Green rather than Willesden Green. But the urban streets of Wood Green are not where the idea for *Pretty Little London* came to life!

A year had passed since their initial introduction to London and Andrea had found an internship as a project manager at a translation company on Oxford Street, with long hours and no pay. He was also working at weekends to pay his rent and writing his master's dissertation. Not the most inspiring of times. After leaving the office yet again at 8.30pm on a warm August evening, life in London, for Andrea, had started to feel unsustainable. Sara was on her summer break from uni and would often wait patiently for him after work, browsing the streets around Oxford Street. That particular evening – fuming, after waiting three hours for Andrea, and having checked out every store in the area – she had had enough. 'You always say you're great at taking pictures, let's buy a camera,' she said, but Andrea couldn't afford one; he barely managed to pay the rent. 'I'll buy it; you can pay me back in photos for my Instagram!' And they went straight to John Lewis to buy their first Nikon, a D3200.

They started to go on long walks after work, exploring areas they had never even heard of, and were stunned by all the things they hadn't seen, even after a year of living in London. They began by looking for inspiration on Instagram. But all they could find were architectural shots of London's landmarks, and they had already realised that London was much, much more than that. On their walks, they found pretty pastel houses, cobbled streets, hidden mews, quirky cafés and vintage markets. If they had spent a year in London and hardly seen anything at all, how many other people were in the same position? Something had to be done – and that is when *Pretty Little London* was born.

It was an instant success.

People related to Andrea and Sara's story and started to tag their account in every pretty photo they took, hoping to be reposted. Quite quickly, *Pretty Little London* became a community, with over 100,000 followers in less than 6 months, inspiring Londoners to explore their beautiful city and create their own inspiring content. Since then, Andrea and Sara have gone even further, dedicating each day to getting Londoners out of their comfort zone and exploring the city, and to finding brands to partner with, which embrace their philosophy, so that they can continue to create beautiful and inspirational content together.

Exploring London and beyond has gone from a hobby to our full-time pursuit, giving us many wonderful opportunities.

So, that is our story, how something that started as a hobby became our life and, ultimately, led to this book. The content that follows is very much an extension of our Instagram account. We have decided to divide it into seasons. Why? Because one of the questions we are most frequently asked on Instagram is, when is it best to go where? So we have put together a little guide to our favourite seasonal things to do in our beautiful city. To be honest, most of the places we have selected are incredible throughout the year, but they evoke special feelings in us when visited at a certain time of the year, as you will discover when flicking through our book.

Anyway, enough from us, now it's time for our photos to do the talking and take you on a journey through our *Pretty Little London*!

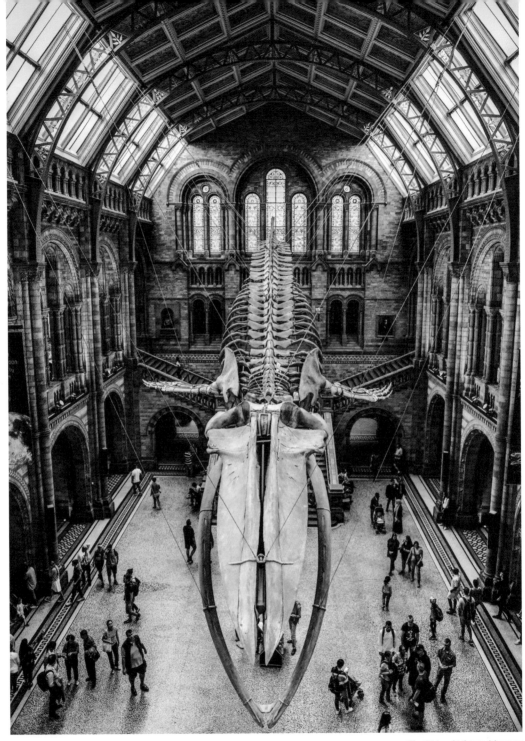

The Natural History Museum

Instagram Tips

Before digging into our book, we thought we would put together some tips
on curating an Instagram account

TIPS TO IMPROVE YOUR INSTAGRAM

Having a curated Instagram account doesn't mean you want to become Insta-famous. You may simply love taking photos. Having a feed that is consistent, colour-coded and aesthetically pleasing can be the best feeling in the world. Engagement comes from good content, but there are some little tricks that can help you maximise how many people see your pictures.

Engage with like-minded people

One of the things we have been doing, since we started *Pretty Little London*, is engaging with people who have similar interests to our own. If you show some interest in others' content with a Like, a comment or a follow, it is very likely that they will engage back. You will be able to create your own little community and you may even find new friends! This approach has led us to meet some truly incredible creators, with whom we have built relationships still ongoing today.

Have your own take on trends

Instagram is very much about trends, so you won't want to fall behind. We like to keep up with new trends, but we give them our own personal touch, so that we remain original. If you have seen the same type of content on your feed for a few days, then you are probably late to the party. If you shoot it in your own style, then it should have originality. Be inspired. Don't copy!

Be authentic

Authenticity is something you will hear a lot about while talking about content creation because it is one of the most important things. Shooting content that is an extension of your personality will make everything more enjoyable and it will result in better pictures. Otherwise – and ask any content creator – you will start hating it as you are shooting to please others rather than yourself.

Hashtags and algorithm

There is no magic formula to defeat the evil algorithm that decides which photos are more relevant than others, but there are little things you can do to maximise your reach. At the end of your photo description add hashtags (e.g. #London #CoventGarden) that are relevant to your content (you can currently post up to 30), but don't always go for the ones with bigger hits. It is probably more likely that you will end up in the Instagram Top Photos with hashtags with lower hits, as you will have less competition. We use a good mix and it has always helped us reach new accounts.

Good photos

Ultimately, Instagram is mainly about photography. This means you can do all the above, but if your photos are not good enough you will never be on top of the Instagram game. So, following is a little photo guide for you. We hope it will help you improve your skills and reach your goals.

Photography Guide

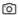

This is a little guide to taking photos when you visit our top London spots. It is both comprehensive and beginner friendly, as we want to help everyone take photos like ours, if they want to.

First of all, we are social media photographers. What does that mean? That all of our photos need to have a story behind them, to express in some way what we are feeling in that particular moment. They are not staged. This differs from professional, staged photography, which can be a little soulless sometimes and, in our opinion, does not fit the purpose of social media.

Equipment

We shoot most of our photos on a Nikon D850, which is an exceptional camera, able to capture quality photos in almost any light conditions. It's a professional camera and on the expensive side, so we would only recommend it if you are an intermediate-level photographer wanting to advance your craft. We also use an Olympus PEN, which is much more manageable and very easy to use. We can't recommend it enough as a first camera, especially when travelling. For lenses, we use a Nikon AF-S NIKKOR 24–70mm for most of our photos, but we also have a Sigma 50mm F1.4 DG HSM Art Lens, which is incredible for portrait photography, as it blurs the background a lot more, compared to a standard lens.

Setting up

If you are shooting with a camera, it is always best to shoot in RAW. Files will be larger, as they are not compressed – which is what happens in the case of a JPEG – but you will have much more space to manoeuvre when it comes to editing. Shooting in RAW means that you are capturing as many colours in an image as possible, which means that if you have taken a photo that is a little too dark, you won't lose colours and quality when lightening it during editing..

Natural light is key when shooting any type of photo, so if you are taking pictures in a restaurant or café, you always want to look for a seat by the window or outside if it's a sunny day. Also, if you are shooting food, or flat lays (shooting objects on a flat surface from directly above), our advice is to pick a theme and focus on a particular colour palette, leaving some space between the food and having the prettiest dish as the main focus. We love to animate our food photos and flat lays by adding motion, maybe pouring some wine into a glass or including a hand, so that it looks less staged and doesn't appear too stiff.

If you are shooting outdoors, the best light is found during the golden hour (or magic hour), which is the period of daytime shortly after sunrise or before sunset, when the light is softer and more red than when the sun is higher up in the sky. Another incentive to shoot during sunrise is that you will have the streets all to yourself. Not something that happens very often in London!

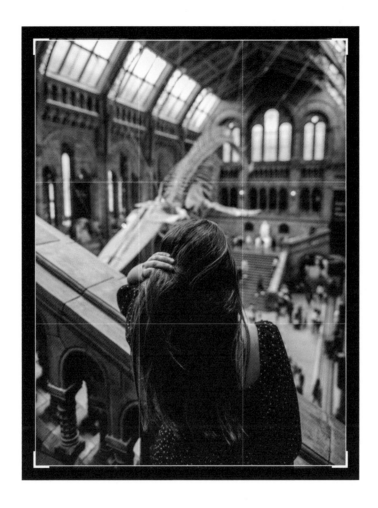

In terms of angles, if you are taking a picture of a person or an object, try to take it so that they are in the middle of the shot and there is equal space on the left and on the right. This will make your photos more symmetrical. Try to shoot with your camera as straight as possible (not with the lens pointing up or down) or your images will appear crooked.

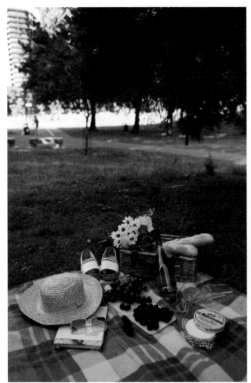

Original photo (left); Pre-set B (right).

Photo editing

Photographers are only as good as their photo editing skills. You can own the best camera in the world, but if you don't get your angles right and lack editing skills, you will never be happy with your content. Our go-to app when it comes to photo editing is Adobe Lightroom.

Lightroom is a free and incredibly intuitive photo-editor app. Here, you can easily edit the brightness, contrast, black and whites, sharpness and much more, without compromising on quality. As mentioned, it is really simple to use so it is probably easier for you to download it and play around with it. A little tip for beginners: if your photo isn't as straight as you would like, you can try adjusting it with the distortion tool in the Geometry tab. Also, if there is a colour you are not crazy about in the picture, you can saturate it out, or change the brightness or the hue by simply going to the Colour tab and clicking on Mix. Selective editing is also possible and is a must for us, but it's not available in the free version.

We use Lightroom for basically every photo we take and we used to edit all photos from scratch. To save time, we have created our own editing kit, which includes our Lightroom settings and means we can copy the them from a previous photo and paste them onto a new one. We noticed that most photos taken in, say, Notting Hill required a similar type of editing, so when we shoot in this location we apply our Notting Hill pre-set, do a few small additional changes and the photo is ready to post.

We have created this editing kit to help you with photos taken in different areas of London, both with a smartphone or camera. This is available to purchase on our website and will help you achieve our aesthetic.

Other than Lightroom, we use quite a few apps for photo editing, but most of them only for small retouches. Snapseed is a good alternative to Lightroom and has some nice filters you can use, and the same goes for VSCO. If you need to quickly remove a small object from a photo, we recommend using Retouch, while if you want to make your Instagram Stories a little more artsy you can download Unfold and StoryArt. For a colour-coded feed, we can't recommend UNUM enough. You can create your feed in advance and see how photos will look next to each other.

Video

Video content is great for Instagram Stories and carousels, to make the viewer feel as if they were there with you. We generally use our smartphone for this type of content, but if we want to do something a little more professional, we use a DJI Osmo Pocket, which is even smaller than a smartphone. With its stabiliser, it helps you create smooth, cinematic 4K video and incredible motion. We also have a DJI Mavic Pro drone and a Go Pro, but we would only recommend getting a drone if you frequently travel to remote or exotic locations, as strict UK drone laws mean you will only be able to use them there and it is quite an expensive toy.

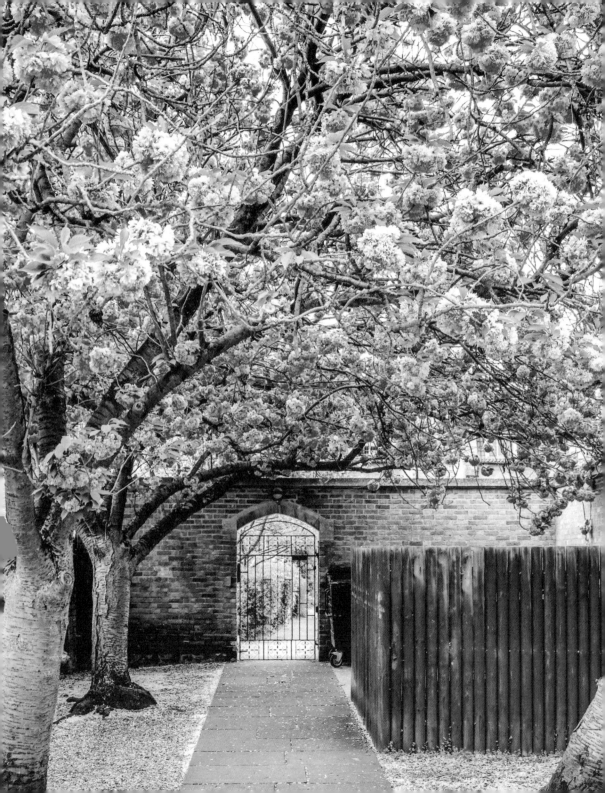

SPRING

ST JOHN's Wood

PRIMROSE Hill

CAMDEN LOCK

⑪

㉒

KINGS Cross

⑬

NOTTING Hill

MAIDA Vale

REGENT's Park

⑰

BT

⑫

⑯

PADDINGTON

BAKER Street

⑤

COVENT Garden

⑱

TRELLICK TOWER

④

The Royal Borough of Kensington and Chelsea
PORTOBELLO ROAD, W.11

⑮

①

Mayfair

SOHO

HYDE Park

KENSINGTON

⑩

CHARING Cross

Elephant & CASTLE

THE

VICTORIA

Westminster

②

KINGS ROAD, SW3

⑲

⑳

CHELSEA

Chelsea Physic Garden FOUNDED 1673

㉓

THE RIVER THAMES

STOCKWELL

RICHMOND & Kew

BATTERSEA Park

THE RIVER THAMES

HACKNEY

LIVERPOOL
Street

COLUMBIA RD E2

SPITALFIELD's

LIMEHOUSE

Wapping

Rotherhithe

THAMES

THE RIVER THAMES

Isle
of
DOGS

THE RIVER THAMES

GREENWICH

The O₂

LONDON
Bridge ⑭

BERMONDSEY

⑨

⑦

⑳

Connaught Village

A WELL HIDDEN NEIGHBOURHOOD FULL OF INDEPENDENT RESTAURANTS, BARS AND CAFÉS

⊖ Marble Arch

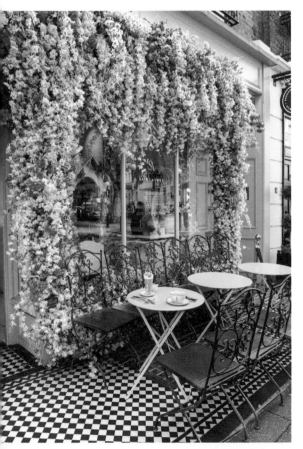
The pretty exterior of Saint Aymes.

We are ready to bet that most Londoners haven't heard of Connaught Village. This quaint district in the heart of London's West End is part of the Hyde Park Estate, just minutes from Oxford Street and Marble Arch. It includes a triangle of streets and has become a sophisticated shopping and socialising destination.

During spring, this area gets particularly leafy and the good weather will allow you to enjoy the many outdoor seating areas of its restaurants, bars and cafés. You'll love the elegant Georgian architecture, immaculate streets, boutique florists and charming hanging flower baskets decorating the streets. Of course, there is also plenty of people watching to do here. Everyone seems to be so incredibly well dressed and stylish! A great perk of the village is its central location, just minutes away from bustling high streets, but yet so peaceful and elegant. We love how the area is a heaven of architectural heritage and exclusive green squares, which make Connaught Village one of London's most desirable communities.

The village is also home to a combination of exclusive independent boutiques, galleries, award-winning restaurants and artisan food.

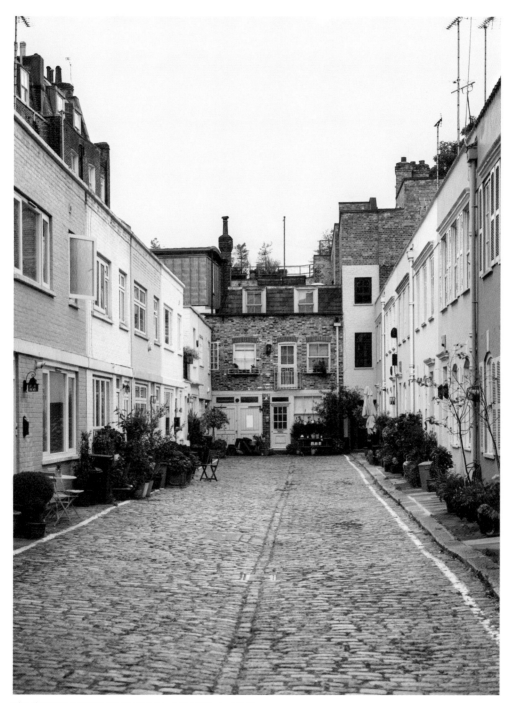

The charming cobbled streets and mews are picture perfect.

The village is made up of a triangle of streets.

Some of our favourite fashion boutiques include ME+EM and The Place London. If you are looking for designs that you won't find anywhere else, Kindare studio and atelier and Kokoro are made for you. Notable is also Lucy Choi, a luxury footwear brand opened by none other than Jimmy Choo's niece. For minimalist and elegant handmade tableware, stop at the porcelain shop Mud Australia.

Getting hungry or fancy a coffee? Connaught Village is not short of places to eat your way around the world – from authentic Argentinian dishes at Casa Malevo to a pint in the sun at the Duke of Kendal. Unmissable is Buchanans Cheesemonger, a quirky cheese shop that offers rare fromages from all around Europe, and Connaught Cellars, which has selected Italian and French wines. A plus is that they also have an incredibly cute dog called Cooper, who is always ready for cuddles. We love how both of these places make you feel at home and their bespoke approach to service is something you won't forget, trust us. Finally, we couldn't fail to include the Instagram gem Saint Aymes, well-known for its 23ct-gold cappuccinos, unicorn pancakes and, of course, wisteria window decorations.

INSTAGRAM TIP
〰〰〰〰〰

Stop by the Duke of Kendal. In front, there's a cute red telephone box for that quintessentially British photo. Nearby, you'll find Albion Mews, a quiet street chock-a-block with attractive houses, some covered in foliage, others painted in lovely pastel colours.

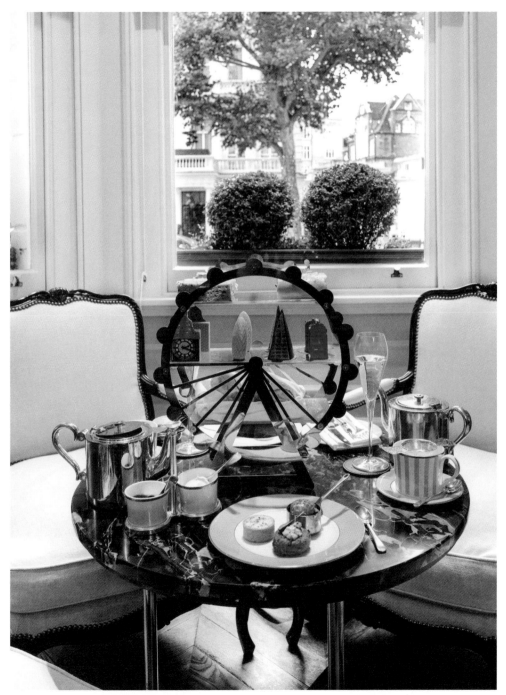

Afternoon tea at The Kensington (see page 24).

Afternoon Tea at The Kensington

VISIT LONDON'S LANDMARKS
THROUGH THIS AFTERNOON TEA

⊖ South Kensington

Serata Hall

PERFECT AFTER A STROLL
IN SHOREDITCH

⊖ Old Street

It is always a pleasure to visit The Kensington hotel during spring, as it creates the most beautiful floral, picture-perfect displays to match the pink blossom lining the streets.

If you are planning a visit to this part of town, then you must stop by The Kensington for its London Landmarks Afternoon Tea in the Town House. Taking inspiration from the city's most famous landmarks, the menu takes you on a 'tour' of architectural gems via its skyline sweets, which are presented on a London Eye-inspired stand.

The afternoon tea lounge is very relaxed in a softly lit room, making you feel at ease with its attractive but homely atmosphere. The staff explain the tea, using a card with drawings of the landmarks on a London map, which you can then take home with you. It would look lovely framed.

Now to the best part of the afternoon tea: the sweets. The selection includes a mini The Shard, made of carrot cake and milk chocolate, a rhubarb mousse red telephone box, a lemon curd tart Big Ben – and our personal favourite, The Gherkin, made of white and dark chocolate ganache. Yum!

Serata Hall is a bar, restaurant and working space just off Old Street roundabout in east London. This bright and airy venue is the latest venture by the people behind Cattivo and Canova Hall in Brixton and Martello Hall in London Fields. As we live in this part of town, we often stop by Serata Hall to catch up on emails and drink bottomless coffee – an excellent incentive.

One of the things we like the most is the on-site bakery, which means that the breakfast is always on point, with such favourites as pistachio croissants, *bomboloni* (an Italian croissant too good to be true!), banana caramel bread, muffins and so much more.

Serata Hall also makes it own pizza dough, pasta and fresh pestos. You wouldn't believe how much better pesto tastes when fresh! And, what about drinks? The cocktail list is quite impressive, and the sherbets, bitters and cordials are all made in-house. If that's not enough, they've even started to make their own gin.

+ INSIDER TIP

Opposite the hotel, you will find one of the prettiest and best-hidden mews in town. Manson Mews is a pastel paradise. You will not be disappointed!

+ INSIDER TIP

Dreaming of blending your own gin, too? Well, you are definitely in luck! Serata Hall runs a fun gin blending masterclass, where you can blend, bottle and name two of your own gins to take away, with the guidance of their master distiller, Jack.

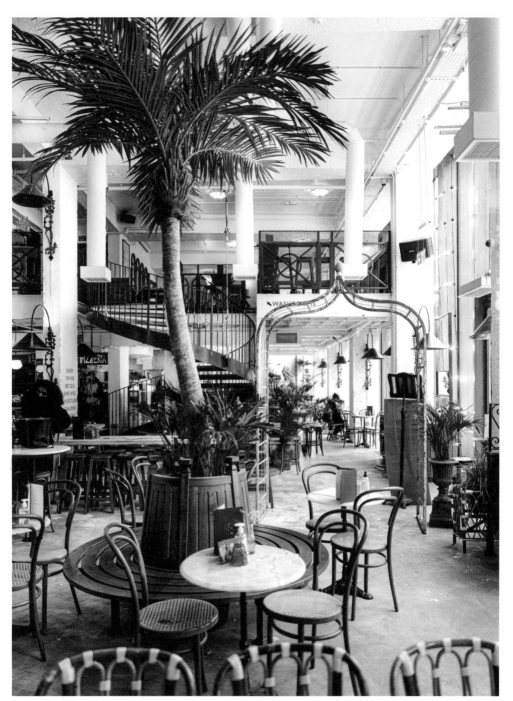

The interior of Serata Hall is bright and airy.

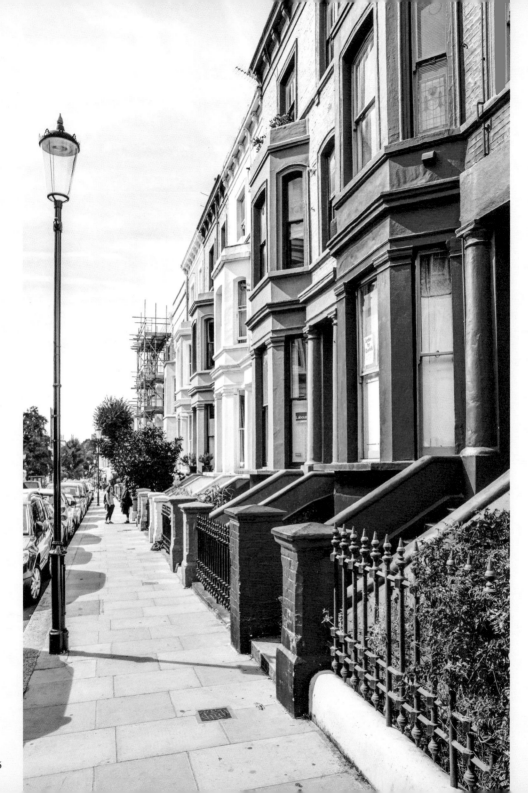

A Day in Notting Hill

EXPLORE THE MOST EYE-CATCHING, INSTA-WORTHY AND FASHIONABLE NEIGHBOURHOOD OF THE CITY

⊖ Notting Hill Gate

Spring in London always reminds us of pastel colours and pretty blossoms, so there is no better place than Notting Hill to get your pink fix during this time of the year. It's easy to fall in love with this neighbourhood's quirky cobblestone mews, vintage vibes and straight-out-of-a-postcard, pastel-fronted houses. Not to forget; of course, that this colourful area is also home to the iconic Portobello Road Market (see page 122) and Notting Hill Carnival. If that's not enough, it's also the setting of the famous movie named after it, where Julia Roberts and Hugh Grant fall in love. But we believe there is so much more than that to explore. We have put together a little guide on what to do on a spring day in Notting Hill, so get ready for a lot of eating, picture taking, shopping and people watching. And who knows? You may even run into your own Hugh or Julia!

Pastel Houses

Images of pastel houses have been at the core of every London Instagram account for years and they certainly make for a perfect picture. Some of the prettiest and most iconic ones can be found along Portobello Road. Enjoy taking pictures, but please be respectful of the surroundings, as people do actually live in these houses. Yes, we are jealous too! Another incredibly cute and colourful street, but in a much quieter area, can be found near Notting Hill Gate station. These residential roads called Hillgate Place and Uxbridge Street, secluded from the hustle and bustle of the main streets of Notting Hill itself, make the perfect Insta-backdrop. You may even spot some Figaros and vintage vans parked on the street. Just off Portobello Road are the more playful hues of Colville Terrace, and if you head towards Ledbury Road and Colville Houses, you'll find softer tones. Also, it might not technically be Notting Hill, but at the end of Portobello Road you will find Lancaster Road, featuring a row of Victorian townhouses painted in the most beautiful shades, from purple to green and even bright red. Nearby is St Luke's Mews, one of the prettiest mews in all of London and where you can find Keira Knightley's pink house from *Love Actually*. Not too far from here you will find another pretty street called Westbourne Park Road, which truly has the most beautiful minty and bubblegum-pink hues. Another super cute pink house can be found on the corner of Pottery Lane and Penzance Place, totally worth stopping by for a picture (if you still have room on your camera roll).

Opposite: Some of the prettiest pastel-coloured houses can be found in Notting Hill.

Blossoms

Notting Hill is full of gorgeous houses, with streets lined with the most beautiful cherry blossoms and magnolias, but where exactly are they, you might ask? Well, absolutely everyone is drawn to take a photo of the Insta-famous pink blossoms' tree on Portobello Road. Found at the beginning of Portobello Road coming from Notting Hill station, it is usually in bloom in early March and the pink door of the purple house behind it really makes it picture-perfect. A lesser known cute tree lives near the pink corner-house in Hillgate Place, between Jameson Street and Kensington Place. Likewise, absolutely beautiful light-pink blossoms can be found in March, in front of an equally beautiful white house in Stanley Crescent. If you are looking for magnolia, which blooms in London, from the end of March to the beginning of April, head to the intersection between Portobello Road and Westbourne Grove, or walk up from Notting Hill Gate tube towards Holland Park.

Restaurants and Cafés

Notting Hill has some of the cosiest and most picturesque cafés in town, making it perfect for both tourists exploring the area and locals alike. Most places are really quirky and Instagrammable, so you will definitely be spoilt for choice. Just at the beginning of Portobello Road is Farm Girl, which serves everything from pink lattes, complete with rose petals, to perfectly decorated salad bowls. Don't expect the greatest flavours but nevertheless it is truly charming and perfect for a friend date. Another Instagram gem is Biscuiteers icing café, with its iconic black and white façade and cute biscuits, perfect for a gift. For pizzas, we

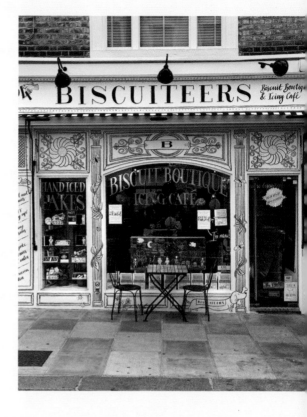

absolutely love Farina – one of the best pizzas in London! Farmacy is great for pretty interiors, has friendly staff and plant-based food. You can't miss their famous healthy 'syringe shots'. Not to miss are also Egg Break and Andina Picanteria.

Boutiques

There are many established fashion boutiques in this stylish neighbourhood, such as Sézane or Reformation on Westbourne Grove, but we recommend you check out the many independent boutiques that you might not find anywhere else. What better feeling than to buy something unique to bring home with you? You will find the trendiest ones on Westbourne Grove and further down on Ladbroke Grove.

Opposite: The pretty pink house from Love Actually can be found in St Luke's Mews

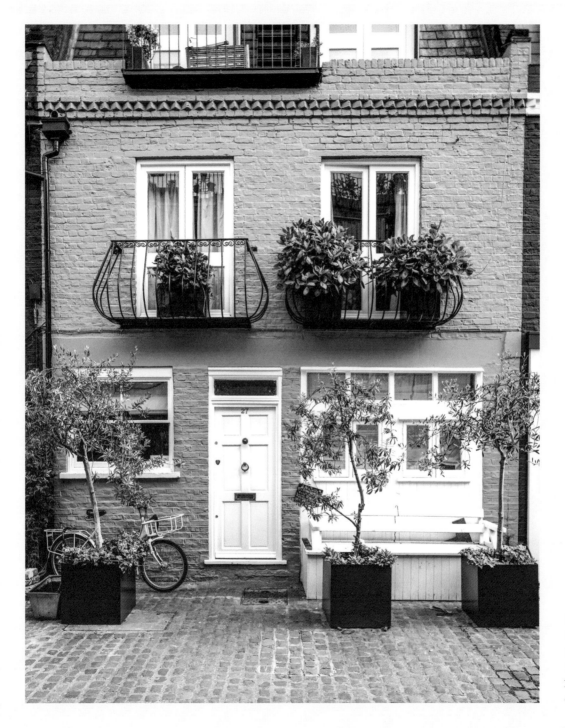

Ye Olde Mitre

A TRIP BACK IN TIME

⊖ Chancery Lane, Farringdon

The Ye Olde Mitre is a pub, well-hidden down a small alley off Hatton Garden, the jewellery district, near Holborn. This historical pub is pretty special as it was built back in 1546 – and it is still running today, although only open during weekdays.

This is one of the most authentic pubs you'll ever see. You'll feel as if you have been transported back in time. The current building dates back to 1773, and the dark wooden furnishings together with the funky decor evoke the atmosphere of an ancient tavern.

But Ye Olde Mitre's most famous feature is probably in its front room, where you'll find the trunk of an old cherry tree. It is said that Queen Elizabeth I herself once danced with Sir Christopher Hatton, an English politician of the time, around this tree!

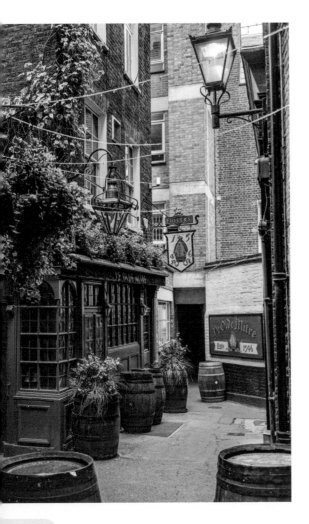

+ INSIDER TIP
〰〰〰〰〰

Pubs tend to get really busy after working hours, and the Ye Olde Mitre is no exception to this rule. If you fancy a pint of fine ale but want to avoid being cramped, we would definitely recommend going just after lunchtime.

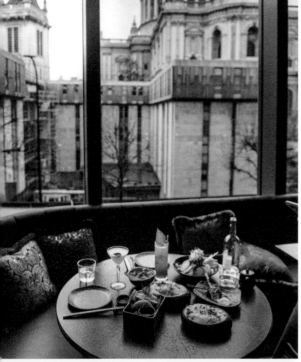

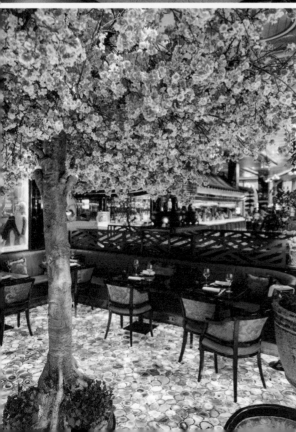

The Ivy Asia,
St Paul's

OPULENCE, MODERN
ASIAN CUISINE AND
ST PAULS' SKYLINE

⊖ St Paul's

If you are a sucker for stunning views and lavish, show-stopping interiors, The Ivy Asia, St Paul's might be right up your street. From the late-night restaurant to the bar, this Ivy will definitely transport you to another dimension. If it wasn't for St Paul's Cathedral, right in front of you, you might forget for a second that you are in London. Though the views are absolutely fabulous, we particularly fell in love with the bright onyx, pink floor at the entrance, the Japanese artworks panelled everywhere and the pink cherry blossom tree standing in the middle of the restaurant. And what better season to visit this place than spring, when all the trees outside are blossoming too? Also, it might seem odd advice, but the loos are definitely worth a visit, not only because they are stunningly blush pink. Look out for the 12ft samurai warrior, too! Trust us!

○ INSTAGRAM TIP
〰〰〰〰〰

For the best photos, ask for a table either by St Paul's Cathedral or by the cherry blossom tree for the perfect spring-like Insta shot. Avoid peak times: we recommend late morning, 11am to 12pm, or after 2pm.

S
P
R
I
N
G

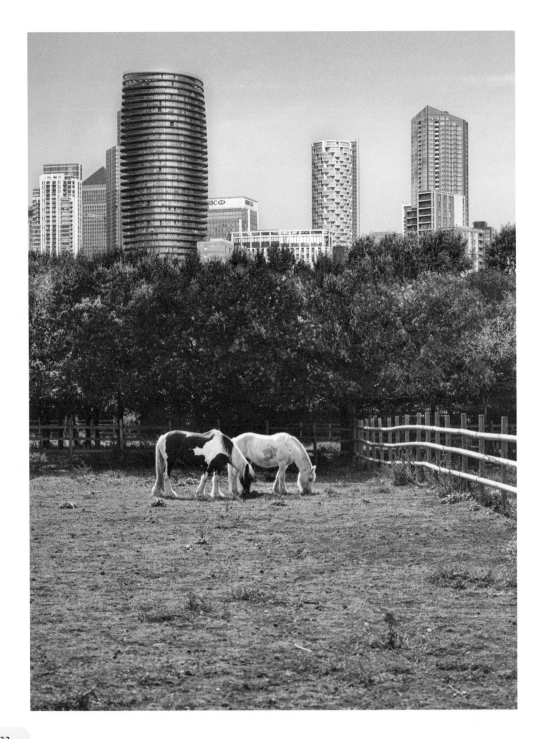

Mudchute Park & Farm

FOR ANIMAL LOVERS, A CITY FARM LIKE NO OTHER

⊖ Crossharbour, Mudchute

We bet you didn't know that London boasts more than seventeen city farms, did you? Well, if you fancy a bit of rural life while you are in the city and want to meet a few cute animals, one of our favourites is Mudchute Park & Farm in the middle of the Isle of Dogs. This farm is so big – precisely 32 acres of land – that you'll have the feeling of being in the countryside (if it weren't for the skyscrapers of Canary Wharf in the background, of course). The farm is quite easy to navigate and you won't lack the chance of meeting a variety of cute animals. Out and about in the fields you'll see sheep, cows and goats, including some rare British breeds. There is also a petting zoo and a duck pond, but the main event is the buzzing Equestrian Centre, where you can learn how to ride a horse, no matter what your age and ability. The stars of the farm are the llamas, so sassy and adorable, but watch out for the spitting! Spring is the season when you'll have the chance to meet some baby animals, including bunnies, sweet little lambs and ducklings. If they don't melt your heart then we don't know what will.

On site, there is a farm shop, where you can pick up fresh organic products to take home and there's a popular café that serves great snacks and breakfasts, where everything is, of course, centred around seasonality. So, sit out in the courtyard, watch the horses gallop by at the nearby stables and get a real taste of the countryside – in London. Farm events include seasonal parties throughout the year, such as the Summer Open Day, a Christmas Fair and even Spooky Halloween. If you need another incentive to visit, the farm is open seven days a week and it's completely free to enter!

+ INSIDER TIP
〰〰〰

Even though day-to-day schedules tend to vary, you can catch the animals eating their breakfast or supper at 9–9:45am and 3–4pm respectively.

The Florist

A GREAT REASON TO HEAD TO WATFORD

⇌ Watford Junction

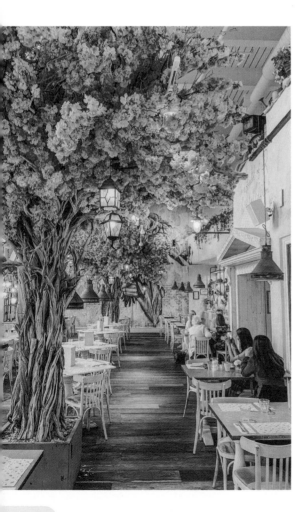

Set in the heart of Watford – yep, it's still London – The Florist stands out for its decoration, vibrant pink tones, entire walls covered with flowers and even a hot-pink blossom tree in the middle of its interior (sadly it's fake). It's an Instagrammer's dream, isn't it? With a drinks menu inspired by English gardens and *Ikebana*, the Japanese art of arranging flowers, the signature cocktails include Rhubarb in Bloom and Peach and Jasmine Sour. Food-wise, you will love the bao buns, perfectly arranged sushi, and mushroom gyoza, while if you are looking for something more traditional, we recommend the homemade blueberry pancakes. On Sundays, they even serve a mushroom and chestnut roast for vegetarians. If the possibility of eating under pink blossom branches is not enough to make you visit The Florist during spring, then you should know about the outdoor balcony areas, decorated – yes – with more blossom trees and romantic lights. During springtime, it is the perfect place to relax and enjoy one of the restaurant's refreshing cocktails. But now, why do we want to send you to Watford, you might ask? Well, you can either do it for the 'gram, or you can make a day of it and take the Harry Potter tour at the Warner Bros. Studios, which are located nearby.

+ INSIDER TIP
〰〰〰〰〰

Driving in central London is a nightmare, so we're sharing a secret. When we need a car to visit the countryside north of London, we get a train to Watford and rent a one there. It means avoiding driving through London's traffic.

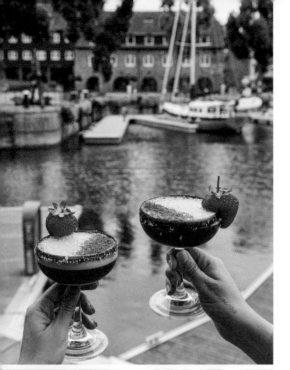

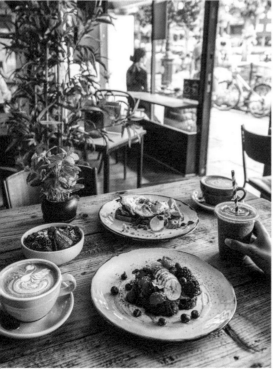

White Mulberries

THE PRETTIEST ESPRESSO
MARTINIS YOU WILL EVER HAVE

⊖ Tower Hill

London's only marina, St Katharine Docks, has become a foodie destination of its own over the past few years, with its well-hidden cafés, restaurants and quirky shops. We always like to visit this part of London when in need of a bit of tranquillity in a postcard setting, especially after a photoshoot on the nearby and rather chaotic Tower Bridge.

Our go-to in St Katharine Docks has to be award-winning coffee shop White Mulberries. This pretty café is located in the historical Ivory House, the only original warehouse still standing in the docks. White Mulberries has everything you dream about when it comes to coffee shops. A charming location, hearty food, vegan smoothies and a signature banana bread. The sandwiches come with all kinds of toppings: Nutella or almond butter to top toasted banana bread, and different types of hummus, avocado and feta for sourdough toast.

Our absolute favourite thing about White Mulberries are the Espresso Martinis. Topped with either whipped cream, chocolate and raspberries or peanut butter, salted caramel and strawberries, they are to die for – and are, of course, picture-perfect!

+ INSIDER TIP
〰〰〰〰

White Mulberries is laptop friendly, and has free wi-fi for customers, so if you are a freelancer or just need a space with a view to send a few emails, then this might just be the place for you!

S
P
R
I
N
G

Wisteria Hunting

 various

If you are visiting London during springtime, you will definitely want to wander around the city hunting for the stunningly coloured, fragrant wisteria that covers many a London building. Unfortunately, this purple beauty doesn't stay around for long, usually less than a few weeks, but maybe that's what makes it so special? It usually starts to bloom just after cherry blossom season, from the beginning to end of April. If you think you'll be the only one out and about, looking for this magnificent flowering vine, then you are wrong. Many Londoners can't wait for this highly anticipated time of the year when, from amazingly covered houses to pergolas in parks, this beautiful climber comes into flower. It even has its own hashtag, #WisteriaHysteria! So, join the trend, grab your camera and follow its sweet scent.

Here are our picks for where you can usually see our most favourite hanging purple flower.

Opposite: Head to Halton Road, Islington, to see the wisteria that covers this picturesque Georgian house.

South Kensington

We recommend starting your wisteria hunt in South Kensington, from Kynance Mews, which is located about five minutes from Gloucester Road station. The mews is home to one of the prettiest plants in the city, which, viewed in contrast to the green door and windows really looks straight out of a fairy tale. This place is beautiful in autumn too, when the arch at the entrance is covered in bright red leaves. From there, walk towards Launceston Place, a picturesque street that has quite a few wisterias scattered along the way. The star of the show, however, is located at Canning Place, a truly majestic house covered in the climber, all the way up to the roof. Just, wow! Proceed towards Kensington Church Street to view another beautiful wisteria and you can finish your walk in Kensington Gardens, which is just around the corner. If you fancy going back towards South Kensington tube station you can also check out Elm Place.

Chelsea

While you are in west London, you should check out Cheyne Walk and take a stroll along the banks of the Thames. There are many attractive houses here, with wisteria trailing along walls and front gates. Also in Chelsea, it's worth going to Christchurch Street, a quiet little square where we spotted some particularly photogenic wisteria.

Notting Hill

Just a stone's throw away from the pub, the Churchill Arms, you will find 4 Bedford Gardens, a much photographed house with a pink door and blue plaque. It's the former home of composer, Frank Bridge. The wisteria decorating its outside is truly magnificent and looks good from every angle. We do wonder sometimes how long it took to grow to cover the house like that!

Chiswick

Just outside the Fuller's Griffin Brewery in Chiswick, you will find what is thought to be the oldest wisteria in Britain. They say it was brought to London from China over two hundred years ago, in 1816, and, well, it is big! It's planted outside what used to be the Head Brewer's cottage, and a cutting was taken and planted in Kew Gardens itself.

Hampstead Heath

There are plenty of wisteria for you to see in Hampstead Heath. Head to Kenwood House and to The Hill Garden and Pergola for some particularly stunning examples. There is also a magnificent house covered in purple wisteria, which grows beautifully on the right side of the wall. Located in Frognal, a small area in Hampstead, dating back to the fifteenth century you'll find it on the corner of Redington Road and Frognal. It's also beautiful in autumn when it is covered in red leaves.

Peckham Rye Park

Unmissable during this season is Peckham Rye Park, located in Southwark. Check out Sexby Garden, where the pergolas are covered in wisteria, heavy with beautiful purple flowers. Walk along the archway for the perfect picture. This park is also perfect for a picnic and it boasts beautiful views over the City and The Shard.

Off the Beaten Track

If you are looking for somewhere less well known, you can head to Eastcote House Garden, in Hillingdon, or to Eltham Palace, in south-east London, where you'll see majestic lilac wisterias dangling from converted passages and antique columns. A perfect Insta-opportunity. For a quiet but more central area, Islington is certainly not lacking in wisterias. Check out Halton Road and the climber-covered exterior of Georgian pub, The Albion (see page 88), for some of the prettiest.

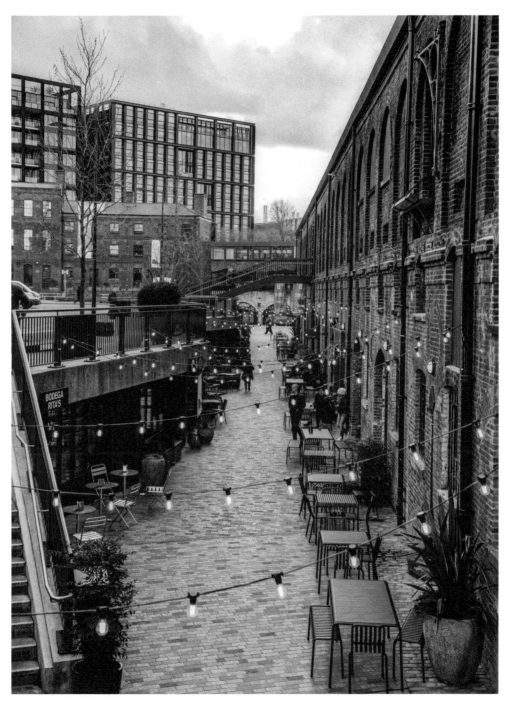

Coal Drops Yard (see page 40).

Coal Drops Yard

FOODIE HOTSPOT WITH COBBLED STREETS AND BRICK ARCHES

⊖ Kings Cross

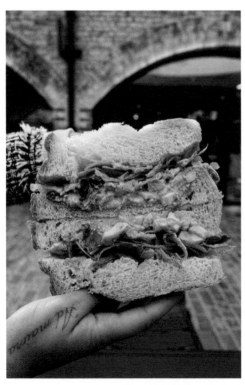

Sons + Daughters are known for their instafamous sandwiches.

Coal Drops Yard is a shopping and dining destination near Kings Cross, which we absolutely love and can't recommend enough. It has a different vibe from any other shopping district in London, with its cobbled streets and industrial feel. Nestled among brick arches, it houses cool restaurants and a mix of independent boutiques and signature brands from the UK and abroad.

All the restaurants in the district are fashionable and delicious. However, we particularly love Barrafina for its authentic but refined Spanish tapas, best enjoyed at the bar, while watching the talented chefs cook in front of you. Also, Coal Office is one of our favourite restaurants ever, with its stylish interiors, tableware (also available to buy) and great atmosphere. The menu is Middle-Eastern inspired and there is a great terrace perfect for al fresco dining when the weather is good. If you are in the mood for a quick bite, we totally recommend Sons + Daughters, which serves trendy and Insta-worthy sandwiches.

After you have lunch, take a wander around all the pretty designer and lifestyle boutiques such as Aesop, the cute Botanical Boys for terrariums, Emin & Paul and Wolf & Badger for fashion, and Caravane and Earl of East for the best interior design.

+ INSIDER TIP

Walk along the nearby canal and you will find the south-facing steps that lead to Granary Square. They are carpeted in green during the spring and summer months, making it the perfect spot to sit with a coffee, relax and watch boats and ducks pass by.

The tapas at Barrafina is best enjoyed at the bar.

Exmouth Market

STREET FOOD AND GREAT VIBES

⊖ Angel, Farringdon

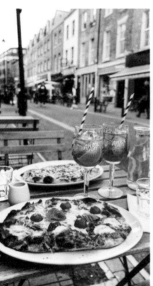

One of London's best kept secrets, Exmouth Market is a pedestrian street in Clerkenwell and home to an outdoor street market with over 30 stalls. About 15 minutes' walk away from Holborn, this incredibly charming street boasts cute restaurants, cafés and bars, as well as design and lifestyle shops. It's a plus that everything is covered with strings of fairy lights that light up in the evening! You wouldn't even imagine that this part of London was once pretty much neglected and considered a bit scruffy.

Since the mid-to-late nineties, this street has undergone an incredible makeover – and we couldn't be happier. Perfect for a lunchtime break or post-work drinks, this street is much loved for its weekday street food stalls, appreciated by nearby office workers and locals alike.

What makes Exmouth Market the perfect destination for a spring lunch or post-sunset dinner is the fact that almost every restaurant and café has outdoor seating, a feature not that common in London. The vibe created is very lively and convivial, almost Mediterranean-like. And talking of Mediterranean, we especially love Paesan, a restaurant serving authentic Italian food. We love sitting outside for an *aperitivo* with a glass of Salice Salentino and some burrata from Puglia. The pasta is unmissable too. Another good italian is Panzo Pizza, with delicious double-cooked Neapolitan-dough pizza, which can be enjoyed outside. We love Morito, sister restaurant to Moro, perfect for sharing small tapas, including *montaditos*, cheeses, fish and other delicacies. Other popular spots include La Ferme for French food and the all-day hangout spot, Caravan. There are also several cute pubs in the area, including The Exmouth Arms.

+ INSIDER TIP

The market runs Monday to Friday. Being food-centred, the stalls focus on lunchtime, from 11am to 2pm. Try to arrive before 2pm so that you can enjoy the atmosphere and enjoy a snack from one of the delicious stalls.

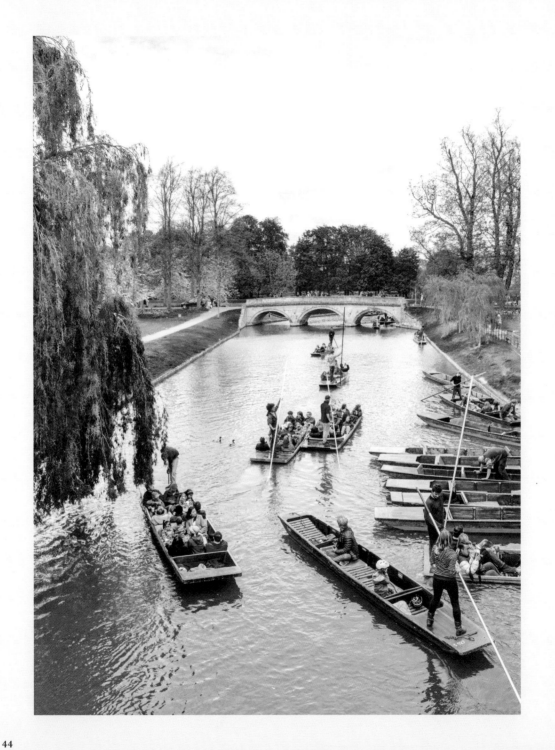

A Day Trip to Cambridge

QUAINT STREETS, ARCHITECTURAL HERITAGE AND CHERRY BLOSSOMS

⇄ Liverpool Street or Kings Cross → Cambridge

Cambridge is one of our favourite day trips from London and given its proximity to the capital, one of the most popular destinations for tourists and Londoners alike — more than 400,000 people visit it every year. The easiest and fastest way to travel to Cambridge is by the express train, which usually takes less than 30 minutes from Liverpool Station or Kings Cross. What we particularly love about the city is that it's covered with blossoms, daffodils and tulips in springtime. Of course, this city is home to one of the most prestigious universities in the world, with illustrious alumni including Sir Isaac Newton, David Attenborough and Stephen Hawking.

Between the quaint streets and heritage sites, make sure you leave some time to check out our favourite blossoming 'Instagram spots' and relax in one of the many green spaces that Cambridge has to offer.

Start your day there with a coffee from The Old Bicycle Shop, a café and bar set in Britain's oldest bike store, Howes Cycles. Other good options are the artsy Espresso Library, an art gallery and a cycling community hub, and Hot Numbers Coffee, which has its own roastery. While you are still fresh and caffeine-fuelled, climb the 123 steps of the Great St Mary's Church for the best views over Cambridge. Then head inside the nearby King's College Chapel to see the largest vaulted ceiling in the world. On the church's doorsteps is the Cambridge Market, a great spot for lunch or an afternoon snack.

Cambridge is a great city to walk in, whether you are following the scholars bicycling around the cobbled streets or getting lost in the different colleges. The feeling of walking around the corridors where the world's greatest minds have changed the course of history and created extraordinary things is something you won't forget! Stroll along the River Cam to watch people punting and head to the prettiest bridges, the Bridge of Sighs and the Magdalene Bridge, to take photos that will look like paintings. Proceed along the river to find another classical view from the Garret Hostel Bridge. The last stop on the River Cam has to be The Anchor, an iconic pub set over the riverbank, perfect for watching the boats pass by, a chilled drink in hand.

If you are looking for something floral, Cambridge is full of wonderful sites. Go to Trinity College for the carpets of red and white tulips and continue on to 'The Backs', the green space behind the colleges, where you can sit on the grass and just chill. Check out Selwyn College for an archway of white blossoms and St Edmund's for cheerful daffodils; they are absolutely everywhere. Be sure to pay a visit to the Cambridge Botanic Garden and for gorgeous wisteria, try Magdalene, Jesus and Peterhouse colleges along with Orchard Street and Willow Walk. Truly an Instagrammer's delight!

SPRING

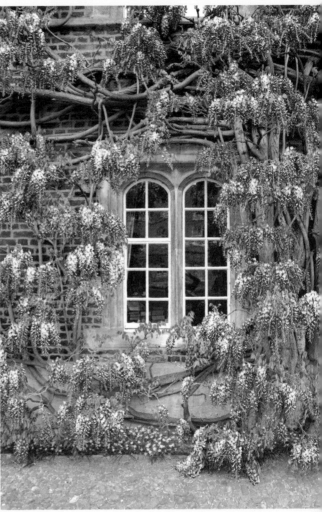

Left: The entrance to Freemasons Hall has an archway of pretty pink cherry blossoms.
Right: Head to Jesus College and you may just see the wisteria.

Bermondsy Street (see page 48).

Bermondsey Street

GREAT COFFEE SHOPS
NEAR LONDON BRIDGE

⊖ London Bridge

In recent years, Bermondsey Street has become one of the trendiest spots in town, a must visit for food and drink lovers with its quirky restaurants, pubs, bars and independent shops. Only a ten-minute walk from London Bridge Station, this street has a history that goes back a thousand years and used to be popular for its wool trading, tanneries and leatherworking.

Bermondsey Street is one of those places you can visit just to take a stroll on a sunny day. The vibe is generally quite laid-back and you can decide on-the-spot what you fancy doing. One of our favourite locations in recent times has been Vinegar Yard, an outdoor space filled with street food stalls, art installations and pop-up shops. It even has a flea market that takes place every weekend.

If instead you fancy a drink, you will be spoilt for choice. The bar scene is pretty amazing and again very chilled, with classy bars full of like-minded people, so forget about the organised chaos of places like Shoreditch and Brixton on a weekend evening. Our personal favourite is Tanner & Co., with its rustic decor, fairy lights and modern cuisine. Also super classy is Bermondsey Arts Cocktail Club, serving pretty and delicious drinks, with live jazz on Wednesdays. When it comes to coffee, a stop at Fuckoffee is needed, with its super artsy interiors and – most importantly – some of the best coffees you will drink on this street. Worth mentioning is Hej Coffee, with its minimalist Scandi decor making it one of the most beautiful coffee shops in town.

After enjoying some time on Bermondsey Street, you may fancy taking some of its vibe home with you. So stop at Bermondsey 167, a lovely little shop full of funky hand-crafted accessories and clothing that change weekly, making for a real treasure hunt.

ⓘ INSTAGRAM TIP

Looking to take a pretty blossoms' shot on Bermondsey Street? Then head to Leathermarket Gardens, as its name suggests, it is the site of the old leather market and tanneries, and you'll find the perfect little angle with The Shard in the background.

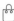

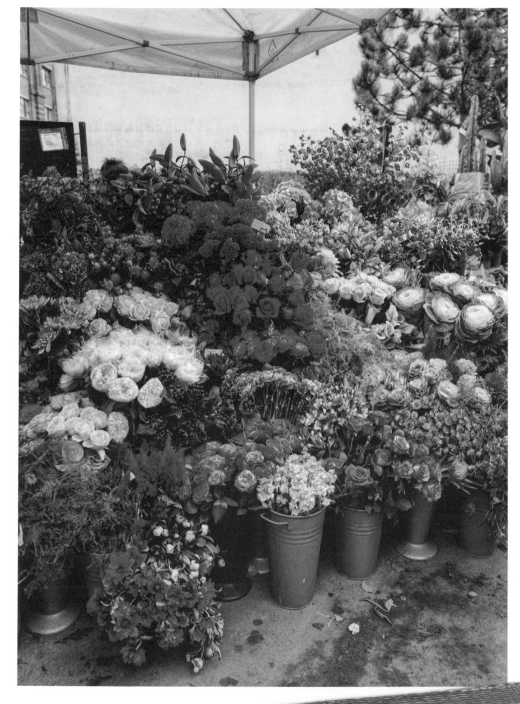

Paddington Central

CANAL WALKS AND
BOAT RESTAURANTS

🚇 Paddington

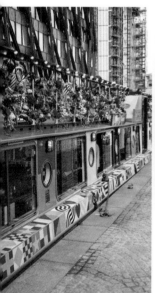
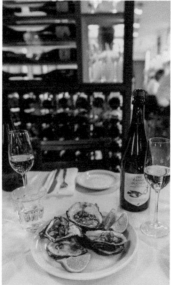

+ INSIDER TIP
〰〰〰〰〰

*London Shell Co.'s The Grand Duchess is truly great, but
how amazing would it be if this beautiful boat actually left
the dock? Well, London Shell Co. own another boat, The
Prince Regent, which takes guests on a journey along the
beautiful, historic canals of north-west London, passing
London Zoo, Regent's Park and through the iconic Maida
Hill Tunnel on the Regent's Canal.*

If, on a sunny spring day, you find yourself
walking along the Regent's Canal towards
Little Venice, you may want to extend your
walk up to the Grand Union Canal and
visit Paddington Central.

Paddington Central is a small up-
and-coming neighbourhood less than
10 minutes' walk away from Little Venice
and 15 minutes from Oxford Street. In
recent years, it has become an attractive
destination to spend time after a long
working day or during the weekend.

For us, it has become a foodie
destination, as many quirky and unique
restaurants are to be found in this area.
There's something for everyone. If you
fancy some supreme British fish paired
with white sparkling wine, then you should
pay a visit to London Shell Co.'s *The Grand
Duchess*, a splendid barge restaurant
with a great ambiance and fun interiors.
If instead you fancy an Aussie brunch
on a floating piece of art, you should
definitely try *Darcie & May Green*. This
restaurant designed by Sir Peter Blake is
the perfect setting for a healthy, relaxing
lunch or for dinner with friends. Another
venue we absolutely adore is Vagabond,
where you can try over 120 wines by the
glass, with new arrivals each week from
the world's best independent winemakers.
This is incredible considering that in most
restaurants, the range of wines that can
be enjoyed by the glass is limited, but here
you can get all of your favourites without
having to buy the whole bottle.

If you want to finish your day on
a high, we recommend dropping by
Pergola Paddington, a secret corner of
West London. Here there are a number
of food and drink stalls with a laid-back
Mediterranean ambiance. Perfect for al
fresco drinks with friends.

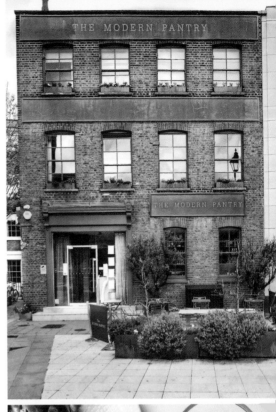

The Modern Pantry

BRUNCH IN A GEORGIAN TOWNHOUSE

⊖ Farringdon

If you are a bit bored of avo on toast and looking for something other than scrambled eggs, but you still want the brunch experience, then we think you'll really like The Modern Pantry. Set within two gorgeous Georgian buildings in Clerkenwell, one a former townhouse and the other one originally part of a steel foundry, The Modern Pantry is not your typical brunch place. The word 'modern' promises something new, fresh and original, while 'pantry' comes from the Latin word *panis* meaning 'bread' and hints at the room used to store household necessities. It is safe to say that you can expect exciting ingredients in combination with everyday recipes and traditional methods of cooking.

In summer, their laid-back outdoor terrace on the ground floor offers you the ideal space to have breakfast or lunch and socialise on a sunny day, while the upstairs dining rooms are more elegant, yet still relaxed, thanks to the abundance of white tones and natural light. Whichever you choose, you'll be guaranteed an excellent experience for your brunch.

+ INSIDER TIP
〰〰〰〰〰

It's almost impossible to eat at The Modern Pantry and not order their famous sugar-cured prawn omelette. We've ordered it way too many times. We probably should try something new, but we love it!

As soon as winter is over and the days get warmer, nothing is better than heading to the park, whether it's for an after work *aperitivo*, a quick lunch break, or an all day long, lazy picnic on a sunny day at the weekend. And one thing we Londoners know how to do is set up a picnic – and Regent's Park is high on our list of favourite green spaces of where to have one.

Located in central London, Regent's Park is popular among Londoners, who head there to enjoy the sunshine, the lively vibe, to people watch and generally get lost in the massive, beautiful space. In the early spring, cherry blossoms are scattered all around the park. If you're lucky, you'll see the Avenue Gardens lined with delicate white cherry blossoms of the <u>Prunus</u> 'Sunset Boulevard' variety, one of the prettiest species of its kind.

The park is large so it won't be hard for you to pick a cute spot for you to set up your picnic. For the perfect picture, we recommend bringing a checked blanket, some grapes, strawberries, maybe some flowers and a few croissants. If you want to take it to the next level, add a picnic hamper, a straw hat or an open book.

A Picnic in Regent's Park

INSPIRATION FOR A SUNNY SPRING DAY

⊖ Regent's Park

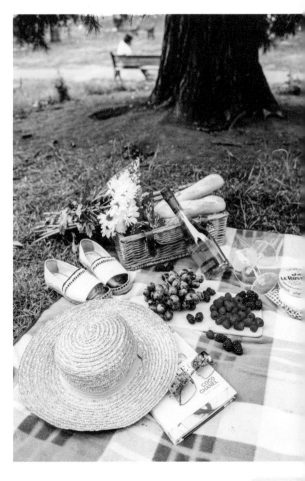

⊙ INSTAGRAM TIP

Some of the best spots are in the south end of Avenue Gardens, where you'll find a sky of pink bubble-gum coloured blossoms in spring, and towards the park's entrance on Chester Road.

Royal Opera House

DRESS UP FOR A SPECIAL NIGHT
AND WATCH ONE OF THE GREATEST
PERFORMANCES OF ALL TIME

⊖ Covent Garden

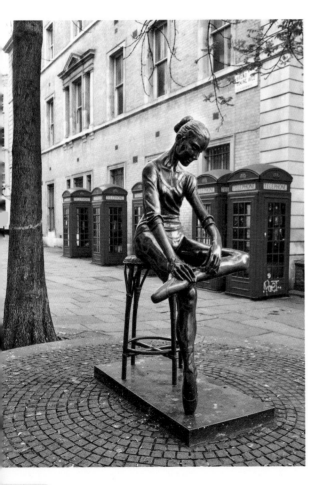

Something we particularly love doing during spring is seeing the ballet or the opera at the Royal Opera House. It's the perfect excuse to venture to Covent Garden, where, usually at this time of the year, flower displays and pop-ups are installed. It's also a great place to eat, especially to have afternoon tea. Set up in the Piazza Terrace Restaurant on the top floor of the Royal Opera House, we believe it's a true hidden gem of the area. If you are in the mood for some scones and decadent cakes, this is the place to be in Covent Garden, but you can also stop by for lunch or just for some drinks. We particularly love this restaurant in spring as the place is so light and airy. When the weather is nice and warm, the windows and doors are left open so that you can soak in some spring sunshine while enjoying your cup of tea. Of course, you can have tea there without having a ticket to the Opera, but what makes the experience truly special is doing both – combining high tea with attending one of the world-famous performances. Definitely something to tick off your bucket list!

⊙ INSTAGRAM TIP
〰〰〰〰

If you are looking for a little-known or secret angle for a photo, head to the bar on the fifth floor. You'll see the prettiest view over the Champagne Bar and beautiful glass arched windows. Try to go there during a performance, as it's busy during the intervals and before and after shows.

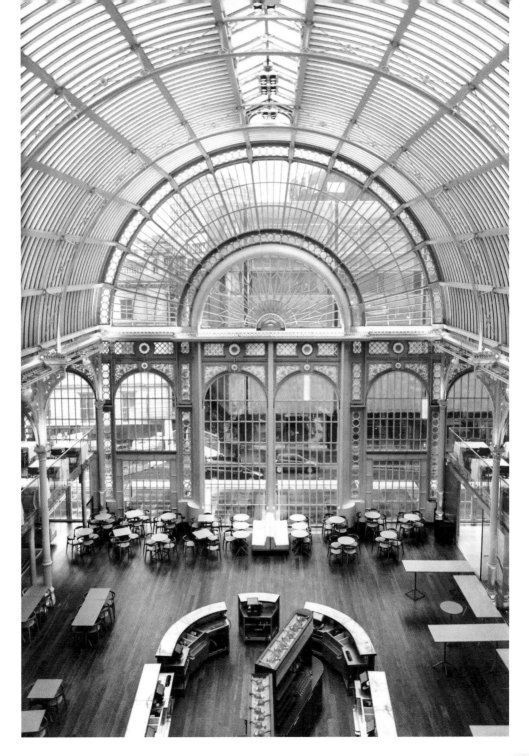

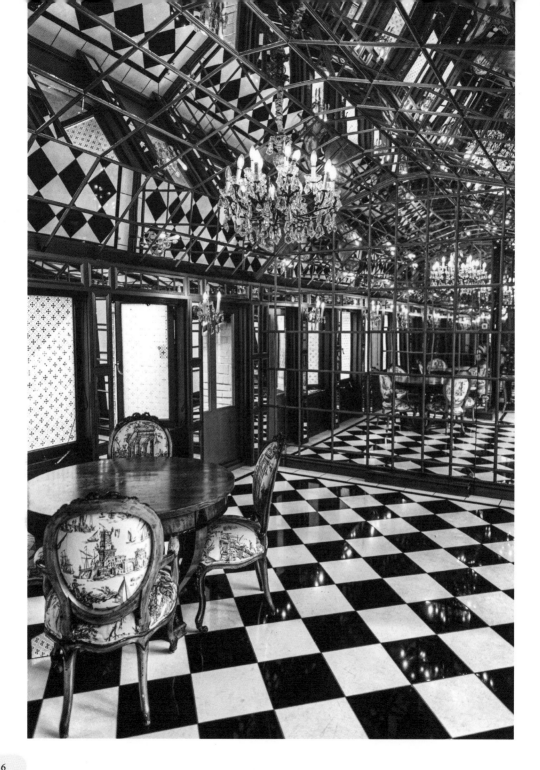

If you are looking to stay in a central but quiet neighbourhood, then 11 Cadogan Gardens is the right place for you. Located in the heart of Chelsea, this quintessentially British boutique hotel is set in a nineteenth-century Victorian townhouse – exactly what many people picture when fantasising about staying in London. This iconic place also has a lovely little story behind it. It was built by Lord Chelsea and was originally made up of four grand townhouses, which explains the quirky layouts made up of countless staircases, corridors and peculiar hallways. If you do get a little bit lost, don't worry, it happened to us too!

With a location so fabulous in this bohemian neighbourhood, it's no wonder that this hotel attracted a wide array of people, from aristocrats and bon viveurs to artists and explorers, looking to establish a home away from home. For a period of time, 11 Cadogan Gardens even housed a private members' club – ah, if only the walls could talk! Renovated in 2019, the hotel has a distinctive style, while preserving its glamorous heritage in its bedrooms and dining spaces. A true gem is the 'cabinet of curiosities' behind the reception, which pays homage to collector and physician Sir Hans Sloane's intriguing collection. Even the restaurant is named after him. It boasts a selection of chocolate-based desserts and drinks, as Sloane is rumoured to have introduced cocoa to the UK.

We love this boutique hotel in the spring, as Chelsea gets particularly leafy during this time of year and it also plays hosts to the prestigious RHS Chelsea Flower Show. In homage, 11 Cadogan Gardens serves cocktails inspired by the spring event of the year. And on sunny days, you can also enjoy afternoon tea on the hotel's terrace or in the conservatory, watching the world go by in your little escape from the hustle and bustle of the city.

11 Cadogan Gardens

TOWNHOUSE HOTEL IN THE
HEART OF CHELSEA

⊖ Sloane Square

+ INSIDER TIP

Just a stone's throw away from the hotel are Sloane Square, The Saatchi Gallery and King's Road, while Hyde Park is a short stroll away. The lovely Chelsea Physic Garden, the third oldest botanical garden in Britain, is about 15 minutes' walk away from the hotel. Stroll along the incredibly pretty Albert Bridge towards Battersea Park, if you fancy some greenery or a picnic.

S
P
R
I
N
G

A Day in Greenwich

VILLAGE FEEL WITH LONDON SKYLINE AND RICH IN CULTURE

⊖ Cutty Sark (for Maritime Greenwich), Greenwich

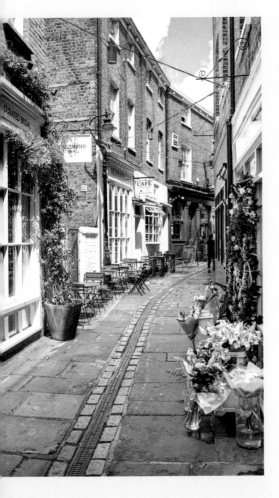

In a big, fast-paced city like London, Greenwich is one of those neighbourhoods that goes at a slower pace, but not in a bad way. Any time we feel like escaping London's hustle and bustle, a day in Greenwich is always on the table.

In this micro-village, everything is close together, making exploring by foot very easy and pleasant. In Greenwich, you will find lovely markets, quirky museums and an abundance of maritime and scientific history. And, obviously, one of the best views over London at Greenwich Park.

We would recommend starting your day at the Old Royal Naval College [1], an architectural centrepiece, where you will find what is considered to be the UK's Sistine Chapel. This spectacular piece of art by Sir James Thornhill is called The Painted Hall, and is one of the most important baroque interiors in the world.

Not as well-known as the naval college, but equally beautiful, is the Queen's House [2] by Inigo Jones. Built in the seventeenth century, this white building contains the famous Tulip Stairs, the first geometric self-supported staircase in Britain. Look up, as soon as you walk in, and you will be left speechless!

Left: Greenwich has a village feel with cobbled streets and bustling alleys filled with cafés and shops.

THE RIVER THAMES

Old Royal
Naval College ①

Maze
HILL ⚞

CUTTY
Sark ④

Greenwich
MARKET ③

Queen's
② HOUSE

GREENWICH

Prime
MERIDIAN ⑥

Royal
OBSERVATORY
⑦

⑤
GREENWICH
Park

⑧

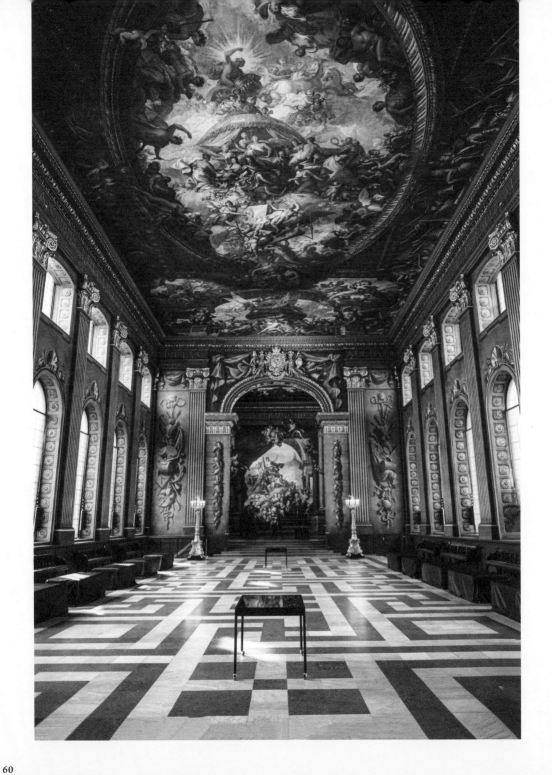

After a morning filled with culture, you will surely be feeling hungry. Head to Greenwich Market [3] for delicious street food from all over the world, including a fantastic choice of gluten-free, organic, vegetarian and vegan options. If instead you fancy a Neapolitan pizza, head to Bianco 43 [4], it's one of the best in London. The other reason to go to Greenwich Market is the unique range of arts and crafts, antiques, vintage items and other collectables. Just remember it's closed on Mondays.

Now that lunch is taken care of, it is time for you to visit our favourite part of Greenwich – its park. Greenwich Park [5] dates back to the fifteenth century and is famous for hosting the Prime Meridian Line [6] and the Royal Observatory [7]. You will get one of the most impressive views over the capital from the top of the hill. So why visit in spring? Because of its avenue of cherry blossoms, of course! Every year, towards mid-April, the cherry blossoms put on quite a show, making you feel almost as if you were in Japan. This avenue can be tricky to find as the park is so big, but if you look up Ranger's House [8], you will find the blossoms right behind it.

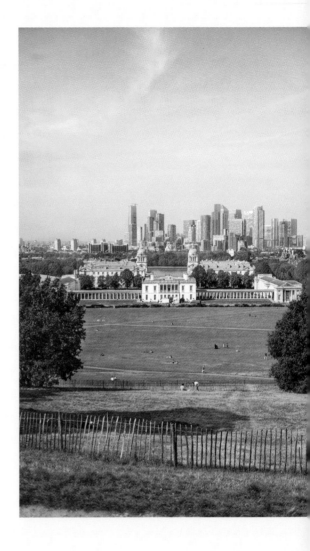

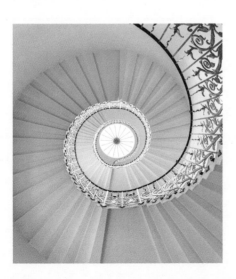

Opposite: The Painted Hall at The Old Royal Naval College. ***This page left:*** The famous Tulip Stairs at the Queen's House. ***Right:*** Climb the hill in Greenwich Park for a view over the capital. For other stunning photos of the area, head to North Greenwich where you can climb up the dome shaped exhibition venue of the O2 Arena. We have done it three times and it is absolutely amazing.

Belgravia in Bloom

THE PRETTIEST BLOOMS IN TOWN

⊖ Hyde Park Corner, Knightsbridge,
Sloane Square

Belgravia is one of London's prettiest and wealthiest neighbourhoods, with its beautiful townhouses and picture-perfect mews. During spring, when the capital is in full bloom, a visit to this part of town feels even more special, as delicate pink cherry blossoms paired with the stunning architecture make for the perfect Instagram moment.

One of our favourite events during spring is Belgravia in Bloom, when shops, bars and restaurants decorate their facades with stunning flower installations, usually created by local florists. This event – usually lasting around a week towards the end of May – runs the same time as the Chelsea Flower Show, considered to be the most prestigious flower show in the world. Strolling along these streets during this time is a must and is a great way to while away a few hours. Pop into Insta-famous cakery Peggy Porschen for some pink cupcakes (you may have to queue for a picture!), Jo Loves for fragrances and Neill Strain Floral Couture for some blooms to take home with you.

As opposed to the Chelsea Flower Show, Belgravia in Bloom is free, which means that there are no excuses for you to fail to wander these charming streets. Your Instagram feed will thank you!

+ INSIDER TIP

After a morning or afternoon spent taking pictures in Belgravia, no one will judge you if you are feeling rather hungry. A little Italian gem we would definitely recommend, il Pampero, makes homemade pasta in a fancy setting. Our favourite dish is Tonnarello Cacio e Pepe *in a pecorino wheel. The risotto with porcini mushrooms isn't too bad either!*

Word on the Water

THE FLOATING BOOKSTORE, THE PARROT AND THE STORYTELLER

● Kings Cross

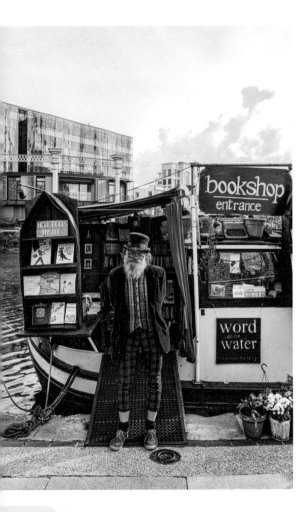

While you are walking along the Regent's Canal on a warm spring day, feeding the ducks, and wondering how your life would be living in one of those boats, your attention will most certainly be caught by one of the quirkiest bookshops in town. Word on the Water is a 1920s' Dutch barge turned floating bookstore, where you can buy all sorts of new and second-hand books. It is currently anchored by Coal Drops Yard near Granary Square, but this hasn't always been the case. Because of canal regulations, the barge had to change its location every couple of weeks, meaning its owners would float around Regent's Canal until they finally found a spot. After a lot of rule breaking, fines and a huge campaign led by their supporters, including sci-fi writer Cory Doctorow, the bookstore was finally given a permanent spot by the canal trust, not far from the British Library.

Word on the Water has become much more than a bookstore since it settled down. During winter, avid readers can get cosy and escape the cold weather outside, while in the summer they host live music, performances and poetry slams from their rooftop garden. Also, did we mention that there is a talking parrot inside? If this doesn't convince you to drop whatever you are doing and head there now, well, we don't know what will.

+ INSIDER TIP
〰〰〰〰

If you see a man who looks a bit like The Mad Hatter from Alice in Wonderland, don't be shy! Ask him to tell you a little story. James will tell you one that you definitely won't forget!

Artist Residence London is a quirky but stylish boutique hotel located in pretty Pimlico, great as a base for exploring London in springtime. In fact, we particularly love and recommend this hotel during the spring months due to its location. Towards the end of May, nearby Belgravia plays host to 'Belgravia in Bloom' (see 62), a free flower festival that brings the neighbourhood to life with its incredible floral installations. For a week, many local shops and restaurants join in and decorate their storefronts with arches of flowers, host special events and even release flower-themed goodies.

Fun fact, the hotel has only 10 bedrooms but they are all unique and accessorised with original art works and eclectic furnishings. Even if you don't stay at the hotel, we definitely recommend checking out its restaurant, Cambridge Street. It's a peaceful hangout for both locals and hotel guests alike, serving everything from quick breakfasts to long lazy lunches, with a menu that changes every season. On sunny days, sit outside on their airy terrace and if the weather is not so nice, get comfy in the warm space inside. The interiors include Shabby Chic cushion-padded benches, reclaimed wooden tables and incredible pop art to keep you entertained while you eat. A little secret is the cocktail bar, deep in the basement of the hotel, a moody and luscious speak-easy cellar-style space. The cocktail menu, not surprisingly, is anything but ordinary – and with drinks named Alice in Wonderland, Charles Dickens and Peter Rabbit, you can expect a few surprises along the way.

Artist Residence London

A QUIRKY BOUTIQUE HOTEL IN BELGRAVIA

Ⓣ Victoria, Pimlico

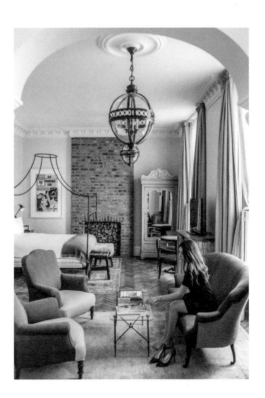

Ⓞ INSTAGRAM TIP

The most Instagrammable room is the Grand Suite. The four poster bed makes a great statement and looks so good in photos! Other details we love are the huge cast iron freestanding bathtub and emerald green sofas.

Mercato Metropolitano

TOP-NOTCH FOOD AND
DRINKS IN A FOOD MARKET
LIKE NO OTHER

⊖ Elephant & Castle

+ INSIDER TIP
〰〰〰〰

If you are going for dinner and drinks on sunny weekends we recommend going as early as 4:30pm to get a seated spot on the outside courtyard. You can always have a few drinks and nibbles first. There are so many things to try anyway! Otherwise, get ready to fight for your seat, as it can get seriously busy.

Ah, Mercato Metropolitano, what a place! One of the greatest and most clever additions to London's foodie scene, this big and airy food market offers a great variety of different cuisines from all around the world. Started in 2015, with a pilot project of regenerating 150,000 square feet of a disused railway station at the World Expo in Milan, Mercato Metropolitano opened its first permanent London location in Elephant & Castle in late 2016, utilising the site of a disused paper factory.

The Mercato is now home to more than 40 food vendors, an on-site microbrewery and even a number of community projects, such as a zero waste cooking school, gin tastings and lessons on 'how to cook a Pugliese feast'. It is also London's first sustainable community food market with a great focus on protecting and revitalising the neighbourhood in which the food hall is set. The market is also designed to be in synergy with its surroundings, and between the use of recycled materials for the interiors and fresh locally sourced ingredients, it is really doing a great job in its social impact.

Now onto the fun things: what to eat while you are there! Well, Mercato Metropolitano is truly big – and trust us when we say big – so we haven't tried everything yet, but here are a few of our tips on navigating it. Starting with the basics, our favourite part, and absolutely perfect for spring, is the outdoor courtyard, full of lush leaves, pretty lights and, of course, many bars and food stalls. There are both shady and sunny spots to enjoy, depending on your mood. Food-wise, our favourites are V for Vegan for absolutely delicious plant-based Greek food; Badiani for authentic Italian gelato; Okonomiyaki serving Japanese savoury pancakes; Molo for seafood burgers; and Fresco Pizza for incredible Neapolitan pizza. Drinks are probably great at every stall but we can personally recommend Jim and Tonic who use gins from their in-house distillery. Some other gems include a themed backyard cinema, a deli from which you can take home Italian delicacies, a yoga studio and even live music on some nights.

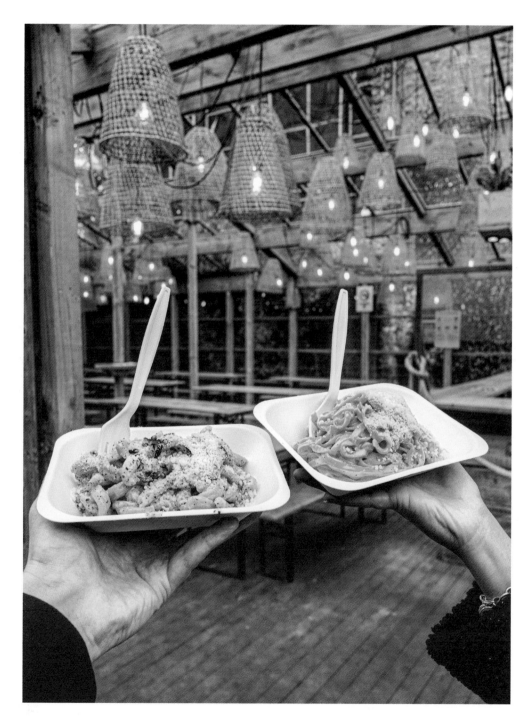

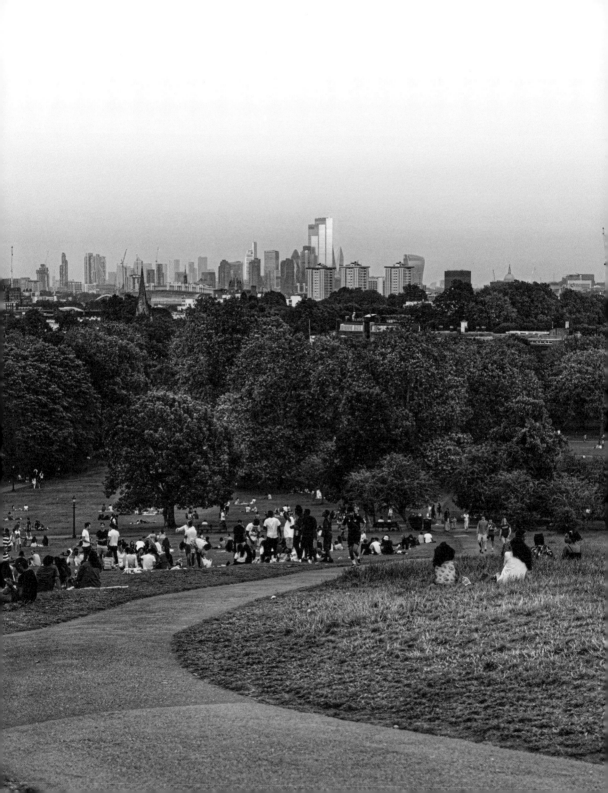

SUMMER

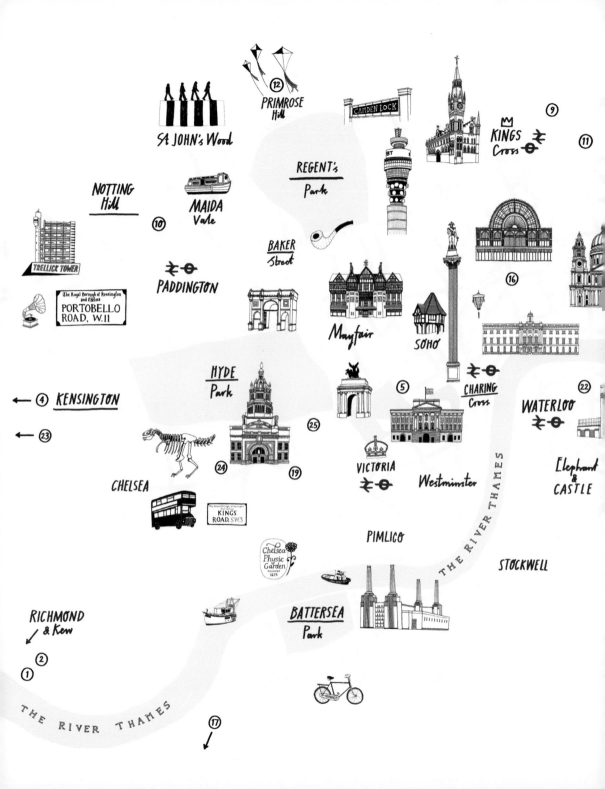

St JOHN's Wood

PRIMROSE Hill ⑫

CAMDEN LOCK

KINGS Cross ⑨

⑪

NOTTING Hill

MAIDA Vale

REGENT's Park

⑩

TRELLICK TOWER

The Royal Borough of Kensington and Chelsea
PORTOBELLO ROAD, W.11

PADDINGTON

BAKER Street

Mayfair

SOHO

⑯

HYDE Park

← ④ KENSINGTON

← ㉓

CHELSEA

⑤

CHARING Cross

WATERLOO ㉒

㉔ ⑲

㉕

VICTORIA

Westminster

Elephant & CASTLE

THE RIVER THAMES

KINGS ROAD, S.W.3

Chelsea Physic Garden FOUNDED 1673

PIMLICO

STOCKWELL

RICHMOND & Kew

BATTERSEA Park

②

①

THE RIVER THAMES

⑰

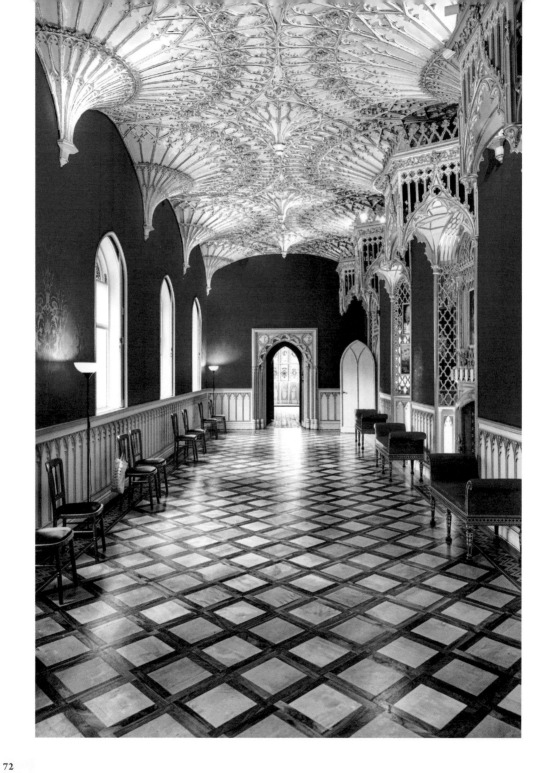

Strawberry Hill House & Garden

A TRIP BACK IN TIME AT A NINETEENTH-CENTURY GOTHIC REVIVAL VILLA

⊖ Richmond

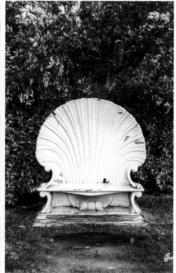

This one is for all of you hidden-gem seekers! In fact, we believe not many tourists know about or have ventured to Strawberry Hill yet, even though it's not that far from Richmond. This magical place is often described as Horace Walpole's Gothic Castle and, indeed, it looks like it has been pulled straight out of a beautiful fairy tale. Built between 1749 and 1776, and then completely restored in 2006 with works finished in 2010, the story of this place begins when writer, art historian and son of the first British Prime Minister, Horace Walpole, discovered 'Chopp'd Straw Hall', on a tranquil hilltop in Twickenham, near the banks of the Thames. He decided to transform what was at the time, just a couple of cottages into his grand vision of what would become his summer residence – a gothic castle, complete with towers, pinnacles and beautiful vaulted ceilings. Dreamy, right?

Inside, if possible, it's even more eccentric and unique, with medieval libraries, hypnotic embellished ceilings and hallways, made to recreate the gloominess of medieval times and both complement and shield the incredible collection of antiques. Why visit in summer, you may ask? Well, it's because of the stunning gardens, which are free to enter. There's an admission fee to visit the house, however. The Grade II-listed gardens are just what you expect from seeing the house: they are stunning, romantic, mysterious and full of beautiful flowers, woodland and other species. We totally recommend stopping for a picnic here, before or after visiting the house – or simply just coming here to relax on a sunny day.

📷 INSTAGRAM TIP

Is this place Insta-worthy? Yes, yes and yes! Head to the Gothic library or take a picture of the red room with its gold and white ceiling and you'll see what we are talking about. One of the best features of the garden is a stunning Rococo seashell-shaped bench recreated in 2012. It will make the perfect Insta-picture, either on its own or with you in it too.

A Day in Richmond

COBBLED STREETS, PUNTING AND THE BEST RIVER WALKS

⊖ Richmond

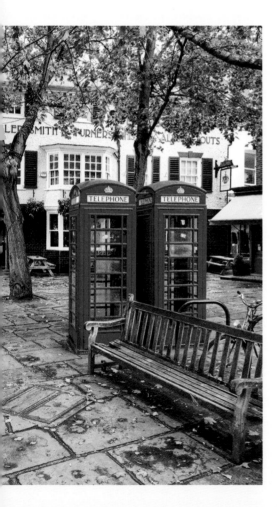

Ah, summer! This season in London truly is a magical time. The temperatures are amazing and everyone is more happy and keen to spend as much time as possible outside. Therefore, we cannot recommend enough taking a stroll around Richmond and, if possible, spending a whole day there. From the many cute pubs to the lovely riverside walks, Richmond definitely won't disappoint. Arrive early and why not extend your visit to gorgeous Richmond Park, the largest royal park in the city, and also nearby Kew Gardens, the Royal botanical gardens.

Walks

With its many walking routes, the borough of Richmond upon Thames is the ideal place to spend time outdoors, breathe some fresh and clean air, and find that perfect photo opportunity. Why not? We are sure that at the end of your day here you won't have any more space left in your camera SD card or camera roll! The beauty of Richmond begins as soon as you leave the train station. You will be transported into a village-like scenery, complete with cobblestone streets and narrow passages. Make a stop at

This page: At Richmond Green you'll find these iconic red telephone boxes. Opposite: As you stroll along the river, you will find cosy pubs and pretty boats.

one just before sunset so that you can enjoy the idyllic peace of your surroundings and hopefully see the amazing colours of dusk reflecting on the water. How incredibly romantic.

Wisteria

We've already talked about the wisteria hysteria of London's spring season, but one of the many beautiful things that adds charm to Richmond in summer is the gorgeous wisteria that covers many of its pretty houses. We totally recommend going for a wander and finding your favourite one and taking a photo. Our beloved purple flower usually blooms in London at the beginning of April until May, so you might catch a glimpse of it if you visit in early summer. Definitely keep your eyes open for the gorgeous wisteria-covered houses and you will have your perfect Insta-picture.

Eating and drinking

Start your day with a lovely breakfast or brunch at Kiss the Hippo, a cute little café with a big focus on speciality coffees and sustainability, which is why you should definitely order their coffee – it's one of the best in London, in our opinion. For lunch, head to the Petersham Nurseries Café where you will dine under bougainvillea and roses in a relaxing yet sophisticated setting, nestled within a gorgeous glasshouse. The food is seasonal, Italian-inspired and oh so good. If you fancy a little shopping, the shop inside the nursery has stunning homewares, from unique vases to candles and glassware, all thoughtfully sourced and selectively handpicked. Also, if exploring Richmond has left you in need of a chilled pint or cider overlooking the river, we totally recommend The White Cross pub, perfect for watching the boats and the people walking on the riverside. Watch out for high tide though, as this pub is famous for flooding when you least expect it.

Richmond Green, where you will see many gorgeous houses and then continue on along the river towards Richmond Bridge, a picturesque eighteenth-century stone arch bridge, to find ice-cream trucks, pretty pubs and charming little boats.

Boats

Talking about boats, did you know that you can actually rent a rowing boat from the pier and take a tour on the Thames? We recommend renting

This page: Kiss the Hippo offers a range of cakes, pastries and breakfast options. **Opposite:** Richmond is full of quaint cobbled streets and narrow passages.

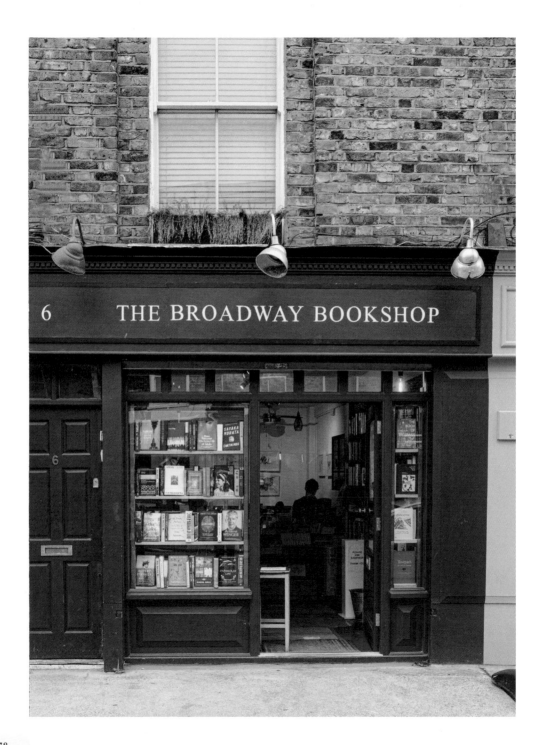

Broadway Market

A PRETTY VICTORIAN STREET WITH UNIQUE BOOKSTORES,
RESTAURANTS AND INDEPENDENT BOUTIQUES

⊖ London Fields

Londoners truly love this trendy east London hot spot, nestled between Haggerston and Hackney and running from London Fields to the Regent's Canal. From its humble beginnings as a muddy road used to bring food supplies and livestock into London, Broadway Market has since become a gem for foodies and fashionistas alike, and we can definitely see why. This pretty Victorian street is full of unique bookstores, amazing restaurants, independent boutiques, fishmongers and greengrocers, among other places, making it an unmissable destination.

Some of our favourite independent shops include East London Design, great for cute jewellery, and Artwords bookshop, where you will find unique tomes on subjects varying from fashion to design and visual culture. We have to stop ourselves from going in too many times as there's the risk that we'll buy up the whole bookstore! The Broadway Bookshop is also a great place to visit. Isle of Olive sells the most eclectic range of Greek artisan products available in the UK, including olives and olive oil, of course, but also raw Greek honey.

As Broadway Market is the only place where even a fishmongers can be pretty, we

Visit The Bach for a delicious and hearty brunch.

recommend stopping by Fin and Flounder, a shop, street food place and oyster bar, where we're sure you'll find something to your taste. The Pavilion Bakery is extremely photogenic, both inside and out, and their sourdough bread is to die for. Our favourite restaurants are L'eau à la Bouche, also a deli, Arabica for coffee, the Market Café and The Bach for hearty and wholesome brunches.

+ INSIDER TIP

At the weekend, you'll find a thriving Saturday market filled with more than 120 stalls including street food, fresh fruit and vegetables, vintage clothing, artisan homeware and pretty flower stalls. It's open from 9am to 5pm, so you will definitely have to pick a restaurant for dinner after all that wandering around. We'd recommend El Ganso for Spanish tapas, great cocktails and outdoor seating.

*Top: Pavillion Bakery. **Bottom:** Market Café.*

Gunnersbury Park

AN OASIS OF SERENITY

⬤ Acton Town

With the temperatures getting warmer, we truly believe that there is no better place to be in summer than a relaxing London park, whether it's for a picnic or a nice long stroll. We found Gunnersbury Park while we were shooting around Chiswick and we needed a place to rest for a couple of hours. We completely swooned at how lovely it is.

It's big, spreading across 75-hectares of the west London boroughs of Ealing and Hounslow. An oasis of serenity in busy London, Gunnersbury Park has become our green space of choice for when we want to feel like we are far away from the city. There is even a little lake where you can rent a boat during the summer months.

With almost no tourists in sight, this place will definitely capture your imagination with the majestic white building at its entrance. Nowadays it hosts the Gunnersbury Park Museum, a large collection of more than 50,000 pieces, showcasing the neighbourhood's heritage, from archaeology to fashion and textiles. The park itself is Grade II-listed and very rich in history. It was formerly part of Princess Amelia's private country estate, George II's daughter, and was later owned by Baron Lionel de Rothschild. It became a public park in 1926 and we couldn't be happier about it!

📷 INSTAGRAM TIP
〰〰〰〰〰

The best place to set up your picnic is next to Horseshoe Pond, in front of the orangery. To get there, head straight down the stairs from the museum and find your way to a small bridge. You'll see a gorgeous white building with a glass roof and window in front of you.

S
U
M
M
E
R

Spencer House

A BUILDING TOO BEAUTIFUL TO BE TRUE

◉ Green Park

If you have rightly decided to head to Green Park, near Piccadilly, on a warm summer day, you may want to drop by Spencer House.

Open to the public on Sundays and right in the heart of elegant St James's, Spencer House is one of those buildings that feels too beautiful to be true. And if you decide to visit, you will find out why. It is London's only eighteenth-century private palace to remain intact and one of the most sumptuous private residences ever built. It is also of great importance when it comes to English architecture, as it is one of the earliest examples of neoclassical design.

This stunner includes eight beautifully restored rooms, including the Palm Room and Lady Spencer's Room, filled with breath-taking chandeliers, sculptures, rare paintings and more. The rooms were designed with big parties in mind as the first Earl of Spencer was very popular, and Spencer House has continued in this vein, hosting magnificent events over the years. The Great Room, with its Corinthian columns, was the site of a ball for Queen Victoria in 1857, while the Music Room provided the setting for a series of charity concerts and exhibitions open to all Londoners during the nineteenth century.

If, indeed, you visit Spencer House during the summer months, you will also want to see the stunning gardens. Here, guests used to be entertained with music and dancing and treated to delicious dinners in the beautifully illuminated surroundings.

+ INSIDER TIP

While you can't use your camera in Spencer House, you will get a chance to test your smartphone photography in the stunning rooms. Keep an eye out for the ceiling in the Painted Room painted by James 'Athenian' Stuart. It's pretty amazing!

Aviary Rooftop

GREAT COCKTAILS AND CITY VIEWS

⊖ Moorgate, Old Street, Liverpool Street

Nestled away on the tenth floor of The Montcalm Royal London House hotel in Finsbury Square, the Aviary features some of the best views over the skyscrapers of the City of London. There is no place we would rather be in the City during sunset in summertime!

The style of this place can be summarised in two worlds: opulent and eccentric. It is still very welcoming though, and on the outside terrace are the views that do all the talking and really steal the show. The cocktails are absolutely delicious and oh so pretty. Try the Peacock Fizz, it even comes with a pretty feather.

The vibe of this place truly changes according to when you go. Straight after lunch is perfect for a coffee break and you will most likely find the place quite empty, perfect if you want to relax or take some nice pictures of the skyline, undisturbed. Due to its location, after work on Thursdays and Fridays is when most businessmen and women from the City flock to the rooftop to enjoy some well-deserved drinks, and it tends to get especailly busy on nice warm days. On the other hand, the crowd tends to be quite different on Saturdays and bank holidays, when the City empties out and it has a little more glamorous atmosphere.

○ INSTAGRAM TIP

You should come here at sunset to get the perfect photo. The light, as the sun is setting over the city, tends to be ideal and if you're lucky you'll capture some beautiful shades of pink. Any time before then, on a sunny day, the light may be a little harsh and create unwanted shadows.

Maltby Street Market

A HIDDEN STREET FOOD MARKET JUST BY LONDON BRIDGE

⊖ London Bridge

We Londoners really do love a good street food market – well, who doesn't? And what better time than a dry summer's day to wander around one, trying to decide on what to eat first? When we found out about this food market, we had to ask ourselves how we hadn't heard about it before. Maltby Street Market is hidden away on, well, Maltby Street, underneath London Bridge's railway arches and operates on weekends only. So, given its central location, it really came as a surprise that we hadn't stumbled across it sooner.

Since we discovered it, we really can't get enough – and we have made it our mission to try all the different foodie stalls in sight. So, if you were wondering what really sets Maltby Market aside from other street food markets, apart from the food, it's the unique setting. The bricked archways, supporting the railway above make it just so picturesque and a few food vendors are even nestled in between the arches, like they're in some sort of secret little hideaway. Plus, you can really tell that a lot of effort has gone into the selection of the vendors, you'll find great food from around the world – including start-ups, as well as more well-known traders. So we are sure you'll find your favourite foods and also discover something you have never tried before!

+ INSIDER TIP
〰〰〰〰〰

Our absolute favourite stall is La Pepiá, serving its famous Rainbow Arepas. Made from white corn, as per the traditional Venezuelan dish, these delicious snacks are blended with natural extracts from spinach, beetroot and carrot to give them colour and a truly unique taste. We love to top them off with a generous amount of their signature melted cheese!

S
U
M
M
E
R

Borough Market

AN ABSOLUTE MUST
FOR ANY FOODIE

⊖ London Bridge

+ INSIDER TIP

Wednesday to Saturday are the best days to go, but get up early to beat the crowds! For a quieter market, visit early, from 10am to 12pm on Wednesday to Fridays; 8am to 12pm on Saturdays. The market is closed on Sundays.

This place is a true foodie's Mecca and definitely an unmissable stop when in London. Borough Market is London's oldest food market and it has been in service in Southwark, near London Bridge, for more than 1,000 years. But even though its heritage is part of its appeal, if you are thinking this place is some kind of old and stiff market, you are totally wrong. Borough Market is trendy, dynamic, with an ever-changing melting pot of international cuisines. It really is a true heaven of exceptionally fresh products, food stalls and delicacies and it's no coincidence that many London chefs and celebrities secretly come to shop here for their restaurants!

Here you will be guaranteed to find unusual things that you probably won't be able to find elsewhere in London. Whether it's artisan ice cream made from goat milk, smoothies made with wheatgrass or hot chillies from Calabria in Italy, Borough Market certainly knows how to keep up with food trends.

You want to eat a paella in London? Check. Fancy trying some of the famous, queue-worthy vegan burgers from The Big V? Check. Dreaming of a raclette served directly from a melting grilled cheese wheel at Kappacasein? Check, check and check.

Some of our other favourite stalls and restaurants there are Bread Ahead for incredible donuts, Portena for empanadas, Monmouth coffee for one of the best coffees in London (the perfect start to your day in Borough Market!) and Horn OK Please for some of the best vegetarian Indian street food we have ever had. Also, Neal's Yard Dairy is a cheese heaven and a Borough Market staple. Once you've finished eating, we totally recommend continuing your day in the area and going for a walk along the Southbank. If the weather is sunny, grab an ice cream from Gelateria 3BIS in Borough Market and proceed towards the Tate Modern, passing by the Globe theatre and arriving at the Millennium Bridge. Oh hello, St Paul's! Continue straight on and you will eventually end up at the London Eye. And we won't judge you if you think it's time for another ice cream already.

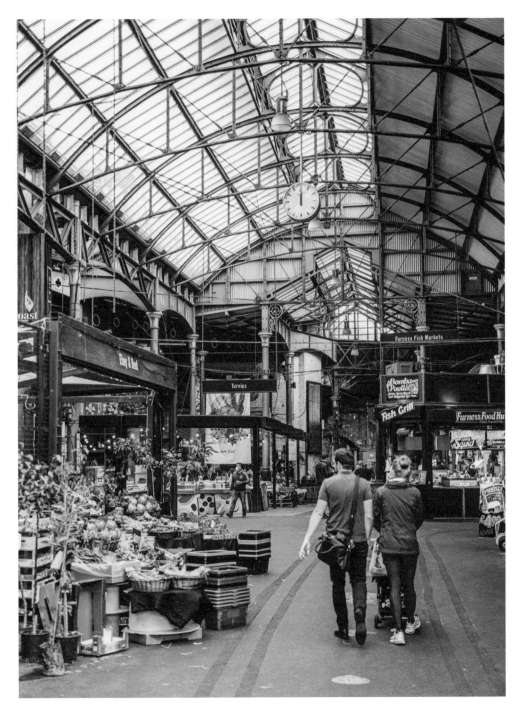

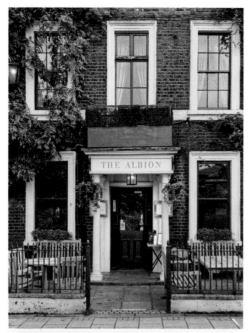

The Albion

ISLINGTON'S BEST-KEPT SECRET

⊖ Angel

The Albion pub is possibly Islington's best-kept secret. Its cosiness is through the roof, and it makes for the perfect venue on a lovely summer evening. This Georgian gem is a relic from the times when Islington was made up of farmlands and fields, and Londoners would come here to take time out of business in the city to relax and have a pint at a local pub. An escape for busy Londoners – so not much has changed over time, right? A façade covered with wisteria (see page 36) makes it picture-perfect and the log fires inside create a cosy atmosphere all year round. But what actually makes this picturesque pub so special is the back garden. The French windows in the restaurant open up onto a dreamy English country garden where you'll be able to relax under a beautiful roof of wisteria and magical fairy lights in the evenings. We are sure you will love this place!

+ INSIDER TIP
～～～～～

Head right from the pub and you'll see Ripplevale Grove, one of the prettiest streets in Islington, full of dreamy period houses. Go down this road for a bit of house envy and take in their perfectly curated gardens and rose bushes. You might even spot some vintage cars parked upfront. This road is truly Instagrammable!

The Hero of Maida is your traditional Victorian pub, situated between Warwick Avenue and Little Venice. Anytime we are in that area shooting content or visiting friends, this is a must stop.

The interiors are picture-perfect and the food is above pub standard, with the chef always managing to rework classic meals (like their Sunday roasts) without getting pretentious and without adding any ingredients that feel out of place. When it comes to drinks, the wine list is well thought through and again offers more quality options than you would generally expect in a pub, without compromising on the beers and ales. To sum up: great interiors, delicious food and great drinks!

We know you will fall in love with this pub and the area, so if you are thinking of staying here next time you are in town, you are in luck. The Hero of Maida has five boutique hotel rooms that have all been individually and uniquely designed. Plus, you can tell your friends and family that you came to England and stayed in a typical British pub.

The Hero of Maida

A PINT, MINUTES AWAY FROM LITTLE VENICE

⊖ Warwick Avenue

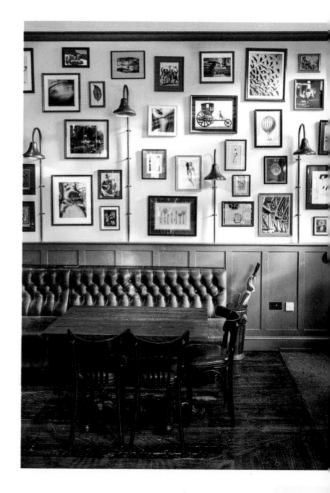

+ INSIDER TIP
〰〰〰〰〰

Every Thursday, different musicians play in the pub, so why not drop by with some friends and enjoy some live music, delicious food and drinks?

A Walk on the Regent's Canal

HOUSEBOATS, WILDLIFE AND TRANQUIL WALKS

⊖ Angel (for the walk)

One of the most interesting walks you can do across London is along the Regent's Canal, which links various interesting parts of the city. Opened in 1820, it was originally built to connect Paddington with the Thames at Limehouse. It takes its name from then Prince Regent, the future king, George IV. Construction was not straightforward. It was a huge and expensive endeavour, but by the mid-nineteenth century, the canal was a major asset to London's economy.

Today, with its tow paths and pretty houseboats, Regent's Canal is an oasis of tranquillity, giving respite to Londoners from the busy streets and traffic, and attracting more and more walkers, cyclists, runners and boaters. We'd recommend escaping London's streets on a hot day to walk down to the canal to recharge your batteries and enjoy the hidden world of interesting wildlife and colourful narrowboats. You will discover a different way of living and spot many cute little places along the way!

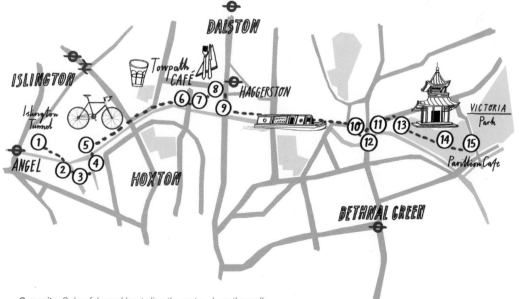

Opposite: Colourful canal boats line the water along the walk.

On sunny summer days, the canal can be very sociable, full of people out on slow strolls or sitting by the path and boaters out on their decks taking in the sun. Talking of boats, did you know that some people actually make these cute boats their permanent residence? Waking up with that lovely view of the river sounds quite idyllic to us, although it can be expensive. The vast majority of those boats require a Continuous Cruiser Licence, which asks 'renters' to move along the canals every other week. If you're looking for a more permanent mooring, the prices go up. Bet it's not the summer breeze you thought, right? For a more affordable taste of canal life, you can join one of the many boat trips that run along the canal and enjoy London from the riverways

Walking Londons canals
There are many guides you can find of the walk from Camden Lock to Little Venice, but we realised that the east part of the canal has not been that extensively covered. The towpath walk from Angel to Victoria Park is one of our favourites, this being our neighbourhood, so we have to give it a special mention. The Islington Tunnel [1] in Angel is the perfect starting point for our walk. Head down into the towpath from Colebrooke Row [2] and probably the first thing that catches your eye are the vibrant narrowboats abutting the tow path. So incredibly cute and picturesque.

Proceed along the path and you will find City Road Basin [3]. Between city views you'll see the Islington Boat Club [4], where both adults and kids can learn how to kayak and sail. They even offer narrowboat trips and paddleboarding. Just a stone's throw away is one of our favourite pubs, The Narrowboat [5]. It's the only pub in Islington that's right on the canal's footpath so you'll understand why we love it so much. You can either sit on the terrace and enjoy a drink in the sun or eat downstairs overlooking pretty boats and ducks passing by in the Wenlock Basin [6].

Afterwards, carry on towards Haggerston and you'll find a true hidden gem, the Towpath Café [7]. This charming canalside café is quite small and has

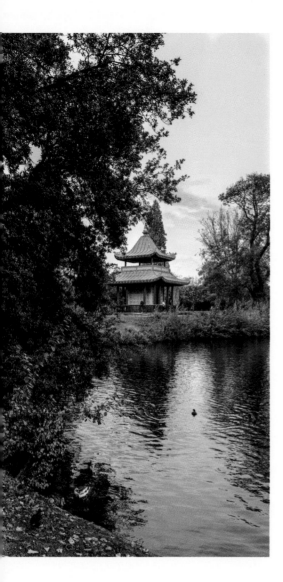

most of its seating outdoors but it's totally worth stopping by, even just for a takeaway coffee for your walk. If you do eat here, we recommend the cheese toastie, for sure one of the best in town. Next door is the equally picturesque <u>Barge House</u> [8], with its floor-to-ceiling windows, home to the Instaworthy 'breakfast in bed' dish, a hollowed-out artisan sourdough loaf, filled with pretty much everything you can imagine. We totally recommend adding a Bloody Mary made with their house-infused vodkas.

Go past Kingsland Basin and you will see on the right the <u>By the Bridge Café</u> [9], an artsy bar full of colourful graffiti and great for fresh smoothies. Another hidden gem, which you'll find along the path, is the <u>Viktor Wynd Museum of Curiosities</u> [10], a tiny but absolutely crazy museum that showcases a unique collection of objects, including occult artwork. It even has a cocktail bar! On the other side of the canal, look out for <u>Ombra</u> [11], a delicious Italian restaurant specialising in Venetian *cicchetti* and fresh pasta made right there. A little bit back from the canal's path, but still very close, is <u>Bistrotheque</u> [12], a trendy modern European restaurant set in a white painted, converted warehouse. It doesn't get any more east London than this!

Back on the footpath, carry on until you see the greenery of <u>Victoria Park</u> [13], where our walk on the canal ends. Enter the park directly from the footpath and from there continue towards the <u>Chinese Pagoda</u> [14]. If you are wondering what a pagoda is doing in the middle of an east London park, well it's the replica of the entrance to a Chinese exhibition that took place in Hyde Park in 1842, which was then purchased after the exhibition. Sadly, the pagoda was damaged during the bombings of World War ll. In 2010, the local borough was awarded a £4.5 million grant, in part to restore the park's landscape. A new pagoda was built and positioned in its original location.

Now, if you think it's time for another coffee – and we think you deserve it after all this walking – head to <u>Pavillion Café</u> [15], grab a seat and simply relax by the lake, watching the row boats pass by.

Opposite page top: Enjoy a drink at The Narrowboat which sits right on the towpath. **Opposite page bottom:** *Barge House is renowned for its signature filled sourdough loaves.* **This page:** *When you reach Victoria Park, look out for the picturesque pagoda which sits alongside a small lake.*

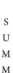

S
U
M
M
E
R

The View from Primrose Hill

UNBELIEVABLE VIEWS AND PASTEL COLOURED-HOUSES

⊖ Chalk Farm

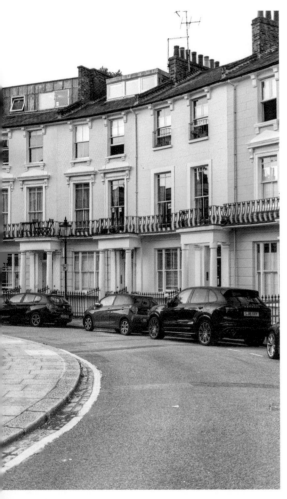

With its village feel, pastel-coloured houses and high-class cafés and pubs, Primrose Hill in the north-west is definitely one of the most coveted residential districts in London. This fancy neighbourhood has been home to many celebrities and historic personalities, especially during the 1990s when Primrose Hill was popular with people in the film, music and fashion industries. So, don't be surprised if, while strolling through this dreamy area looking for the perfect Insta-worthy angle, you bump into Jamie Oliver, Daniel Craig or Jude Law!

If you are still not convinced about venturing to this part of town, there aren't many things as rewarding in London as the 78-metre ascent of Primrose Hill itself. Because of the closeness to central London, you will have a clear view of some of London's most spectacular landmarks, such as The Shard, the London Eye, BT Tower, St Paul's Cathedral and the City's skyscrapers. We can't think of any better excuse to grab some beers and a picnic basket and head with some friends for a nice summer picnic on the grass, to enjoy this beautiful view of London below the setting sun.

+ INSIDER TIP
〰〰〰〰〰

As well as things to do in Primrose Hill itself, it's ideally located near other interesting sites, such as Regent's Park and the ZSL London Zoo. You can walk along the lovely canal to Camden and visit the iconic Camden Market – and talking of markets, Primrose Hill has one every Saturday!

Afternoon Tea at Shakespeare's Globe

RELIVE A MIDSUMMER NIGHT'S DREAM

⊖ London Bridge

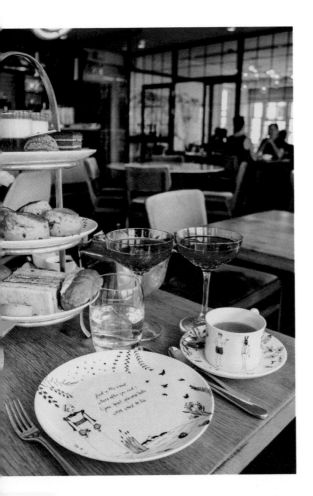

For centuries, London has had a reputation for having one of the best theatre scenes in the world, driving millions of Londoners and tourists to its shows each year. Therefore, it probably won't come as a surprise that at Shakespeare's Globe theatre, on the bank of the Thames, you can enjoy a Midsummer Night's Dream- themed afternoon tea.

A must for all Shakespeare and British-tradition lovers, it's inspired by the characters in Shakespeare's great romantic comedy of the same name, and their journey, making you feel as if you were eating your way through the twists and turns of this exquisite play. You can eat your way through the delicate woodland flavours that evoke the play's setting, such as mushroom, lavender and elderflower, while the scones are filled the mulberries, like those from the lover's tree, and apricots flavour the jam, like the fruit Titania feeds to Bottom. The tea is served on bespoke crockery, reflecting the themes of the play.

This specially themed tea is incredible – and have we mentioned that all the ingredients are sourced from local suppliers and producers? The location, perhaps, is even better! Shakespeare's Globe enjoys beautiful scenic views over the Thames and St Paul's Cathedral, so if you have decided to tick this afternoon tea off your bucket list, be ahead of the game and reserve one of the tables with a view for that perfect snap.

+ INSIDER TIP
~~~~~~~

*We really can't think of a better gift for a theatre enthusiast than spending a day at Shakespeare's Globe, watching a play or going for a fascinating behind-the-scenes tour of the unique 'O shaped' theatre. Obviously followed by the Midsummer Night's Dream-themed afternoon tea, of course!*

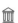

# Tate Modern

MODERN ART AND COFFEE WITH A VIEW

⊖ London Bridge

🏛

The Tate Modern is among the best modern art galleries in the world and, with 5.9 million visitors each year, it is definitely one of the most visited. It holds the Tate's collection of modern art from 1900 to present day and displays it by theme rather than chronologically. The artworks and displays change quite frequently; the Tate's own collection is supplemented by visiting exhibitions, and it is a good idea to check what is on before going.

The location of the Tate Modern is impressive, situated as it is on the Southbank, by the Thames, and opposite St Paul's Cathedral and the Millennium Bridge, the steel suspension bridge linking the banks. We often visit during the summer to escape the heat after a walk along the Thames or to have lunch or a drink in its cafés and restaurants. Not once have we left the museum without experiencing something incredible and innovative.

📷 INSTAGRAM TIP
〰〰〰〰〰

*Millions visit the Tate Modern every year, but few know about the Kitchen and Bar on the sixth floor! Here you can enjoy a coffee and watch the world go by, with probably one of the best views in London.*

S
U
M
M
E
R

# Bar Douro

AZULEJO TILES, PORTUGUESE
WINE AND PASTEL DE NATAS

🚇 Borough, Liverpool Street (City branch)

We have definitely had some of the best things we have ever eaten in our entire lives during our trips to Portugal. Ah, that *bacalhau à brás*, grilled octopus and those Pastéis de Nata – we're still dreaming about them all. And the wine, it's so good! Considering how delicious the country's cuisine is, why is it so hard to find a good Portuguese restaurant in London? It's probably down to the fact that there aren't really that many.

Bar Douro has managed to fill that gap and is relatively new in London's foodie scene. The first restaurant opened in London Bridge's Flat Iron Square in 2016 and, after its incredible success, a second one opened in Broadgate Circle, Bar Douro City. When you walk into the bars, you're magically teleported to Portugal, thanks to the beautiful interiors filled with hand-painted Portuguese *azulejo* tiles, alongside marble counters from Aveiro and traditional mosaic floors made from hand-cut *calçada portuguesa* stone.

Produce is the main word in Bar Douro. Ingredients are imported directly from Portugal, from small artisanal producers. The wine list contains London's largest selection of Portuguese wines, with a focus mainly on small independent winemakers – meaning most of them you will only be able to drink here.

For the reasons above, Bar Douro has quickly become a wine hotspot, and its Broadgate Circle restaurant is the perfect location to sip some white wine or rosé during those (rare) hot summer days.

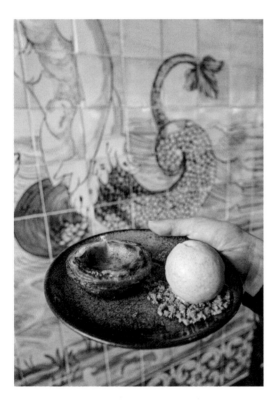

📷 INSTAGRAM TIP
〰〰〰〰

*Bar Douro is truly picture perfect, but if you want to capture an empty restaurant you will have to go at opening time, or you will probably be disappointed.*

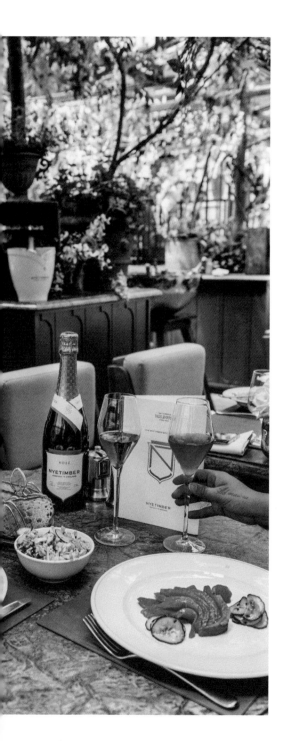

# The Terrace at Rosewood London

## AN ESCAPE FROM THE HUSTLE AND BUSTLE

⊖ Holborn

The Rosewood is definitely one of the most notorious hotels in our beautiful city. It is well known for the artistic Scarfes Bar, its majestic staircase and luxurious rooms. Not many know though that the hotel also features a stunning terrace tucked away in the historic Edwardian courtyard.

Every year, during the summer months, the terrace changes its look and one of the things we look forward to the most is seeing how it's been transformed. While the styling may change according to the sponsor, the unique food and cocktails, all prepared in The Holborn Dining Room, remains consistently good.

If there is someone special in town or if, like us, you simply want to relax with some fresh air, this secret garden is a great spot to escape the city's hustle and bustle.

+ INSIDER TIP

*Another must at The Rosewood is the Art Afternoon Tea in the Mirror Room, inspired by the work of some of the most famous artists, such as Banksy, Pablo Picasso and Andy Warhol. It changes quite frequently and it always manages to surprise us.*

S
U
M
M
E
R

# A Day Trip to Mayfield Lavender Farm

## INCREDIBLE SCENTS AND LAVENDER ICE CREAM

London Victoria → Cheam (then a taxi)

Whether you are a Londoner or simply visiting the city for a few days, one thing we know for sure is that, at some point, you'll want to take a road trip to the countryside. A day trip from London that we always recommend during summer is to the Mayfield Lavender Farm. Less than an hour from central London by car, in Banstead, Surrey, this 25-acre organic lavender field is a must during summertime. We love to wander through the sea of beautiful plants found here, take pictures and breathe in all the incredible scents.

We love to stop by the farm's café to enjoy an al fresco lunch on their picnic benches and tables. Highlights of the café include a lavender cream tea, a barbecue during July and August, and their unique homemade lavender cider! Don't miss the cute on-site shop where you can buy lavender plants, homemade lavender soap, lavender oil, many culinary treats such as biscuits and teas, and, of course, beautiful bunches of fresh lavender.

Mayfield Lavender farm is usually open for the season seven days a week from June to August but we would recommend stopping by in July, as this is when the lavender is blooming. If you are planning to take some nice photos, and we totally suggest you do, try to avoid weekends as it can get very busy!

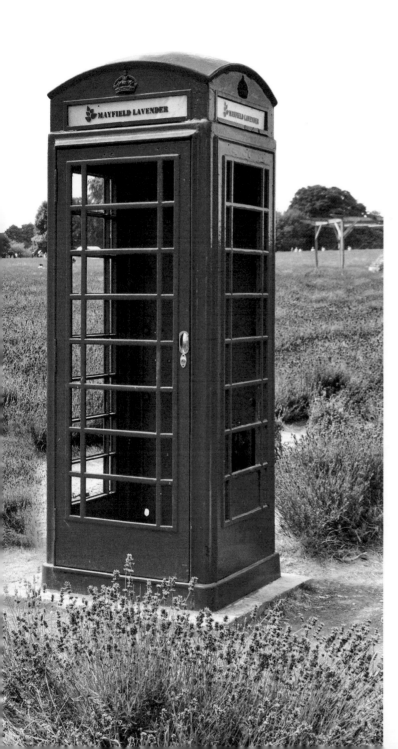

*Left:* There's actually a red telephone box in the middle of the fields, believe it or not, so make sure to take your camera out for that photo op. Ice creams make other good props for pictures so make sure you grab two lavender cones from the café and take a picture with the matching lavender fields in the background.

# Broadgate Circle

A VIBRANT FOODIE SPOT IN THE CITY

⊖ Liverpool Street

Broadgate Circle is definitely our go to place in the City when we are looking for great vibes and good food at the weekend. Located between Liverpool Street Station and Finsbury Avenue Square, Broadgate Circle is home to some of London's most fashionable restaurants, cafés and bars, including Bar Douro (see page 98). We especially love it on a Thursday or Friday evening, when it's bustling with people after work.

As it is an open space, in summer it's a truly perfect place to grab a drink and just chat away in the sun before heading to dinner in one of the many nearby restaurants. Talking of dinner, our favourite places for food there are Shoryu Ramen, for what some people say is the best ramen in town (we can assure you it is pretty good), Beany Green, a pretty Aussie-inspired brunch place, and Yauatcha City for fancy dim sums. In terms of drinks, we love Grind, which is great not only for coffee but also for pretty amazing Aperol spritzes and lychee and espresso martinis. We also adore Mrs Fogg's Dockside Drinkery & Distillery – which is an experience in itself – with creative cocktails and an Indian fusion food menu in a nautical-themed bar that will make you forget that you're in the busy City.

Broadgate Circle also hosts many cool events and pop-ups throughout the year, so we definitely recommend checking out their calendar so as not to miss out on anything fun.

+ INSIDER TIP

〰〰〰〰

*Broadgate also includes the nearby Finsbury Avenue Square, Bishopsgate, Broadgate Plaza and Exchange Square. There are many food trucks scattered around and restaurants we haven't mentioned. During summertime, Londoners love to sit in Exchange Square after work, sipping on a Pimm's and watching tennis on the big screens that are erected. If you are lucky, you can even catch Wimbledon in July. It's almost as good as being there!*

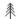

# Belmond Cadogan Hotel

## LIVE LIKE A LOCAL IN A CHELSEA TOWNHOUSE

⊖ Sloane Square

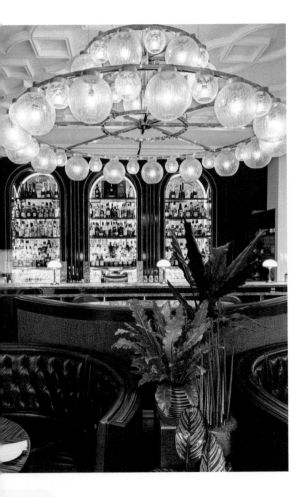

The Cadogan Hotel first opened in 1887 and is located on Sloane Street, halfway between Chelsea and Knightsbridge. It comprises five townhouses that all used to be owned at some point by Lillie Langtry, celebrated actress and socialite of the time. What makes this hotel famous is the arrest of Oscar Wilde here on 6 April 1895, after he lost a libel case against the Marquess of Queensberry.

Today, The Cadogan Hotel provides stunning five-star accommodation. Owned by the Belmond chain, it offers fine dining and glamour from a unique position on Sloane Street. But what makes this hotel even more special and exclusive is its access to the private Cadogan Place gardens, usually reserved for locals, but available to hotel guests. So, while Londoners go crazy during a rare heatwave, you will be able to enjoy Pimm's, deckchairs and boardgames in the sanctuary of these tree-lined, nineteenth-century private gardens. And if you get bored, there are tennis courts too.

Not to far is the Chelsea Physic Garden, originally known as the Apothecary's Garden. Established in 1673, this is one of the oldest botanical gardens in Britain and is home to some 5,000 different medicinal, herbal, edible and useful plants. It also runs a variety of events and workshops throughout the summer, if you are keen to get your hands dirty!

+ INSIDER TIP
〰〰〰〰

*The hotel's position makes it a dream for any shopaholic. It's literally a five-minute walk away from Harrods, but even better, it faces directly on to Sloane Street, ideal if you want a more relaxed shopping experience..*

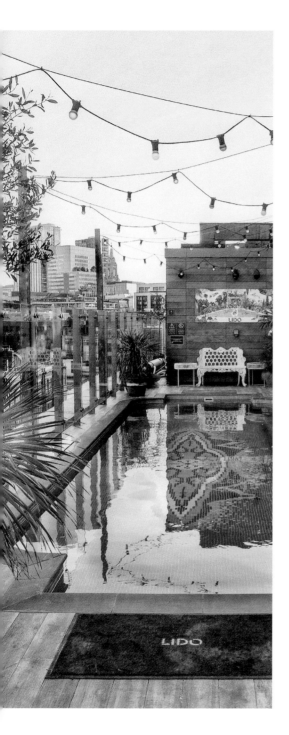

# Mondrian Shoreditch

### THE BEST POOL WITH A VIEW
### IN EAST LONDON

⊖ Old Street

If there is one hotel you must stay at in London during summer, it's definitely the Mondrian Shoreditch. Located in trendy East London, this newly rebranded Mondrian hotel, formerly The Curtain, marks the brand's return to the capital and it's a mix of warehouse luxury and great design. It's also a music venue and members' club. Think photogenic exposed bricks, lush greens and large windows which give the hotel a Manhattan-inspired, super-cool vibe.

So, what makes this hotel the perfect choice for a summer stay in the city? Well, it's the laid-back rooftop lounge Rumpus Room, which specialises in amazing cocktails, and, possibly the best feature of the hotel, the Moroccan-inspired heated pool. The rooftop has a retractable glass roof so that on hot days it really feels like you are relaxing by a pool somewhere exotic. Just imagine fairy lights, sun loungers, lush plants and London's skyline. You can also come up simply to read a book or to work on your laptop in total relaxation.

+ INSIDER TIP

*The rooftop is currently open for hotel guests and members only. It makes it the perfect escape from the crowds if you decide to stay here as it won't be too busy during hot days when everyone dreams about dipping in a pool on a London rooftop. Talking about the perfect staycation!*

S
U
M
M
E
R

# Drinks at Madison

UNIQUE VIEWS OVER
ST PAUL'S CATHEDRAL

⊖ St Paul's

Nothing screams summer in London more than an Aperol spritz on a rooftop bar overlooking the City skyline, don't you agree? We can say without any doubt that most Londoners have their own favourite rooftop, which they always go to and recommend to friends passionately. We love trying out as many as we can on those hot London days and we can truly say that Madison's jaw-dropping terrace bar and lounge overlooking St Paul's Cathedral is a must. The great vibe and music make it the perfect destination if you are looking for a more party-like and glamourous atmosphere to have fun in.

Go after lunch for a more chilled vibe or during the weekend for the in-house DJs and live music. Just check the calendar on their website to see what's on.

To go up, simply arrive at One New Change in St Paul's, take the elevator to the rooftop and voilà, you'll find yourself face-to-face with one of the most beautiful cathedrals in the world!

◉ INSTAGRAM TIP
〰〰〰〰〰

*Go as the sun is setting for the perfect picture and order two of your favourite drinks. Aperol spritzes make for a perfect summer photo, but anything else will work too. If you are not too bothered about having the drinks in the picture, you can still take a beautiful picture overlooking St Paul's Cathedral – go up to the One New Change rooftop, next to Madison, which is free of charge.*

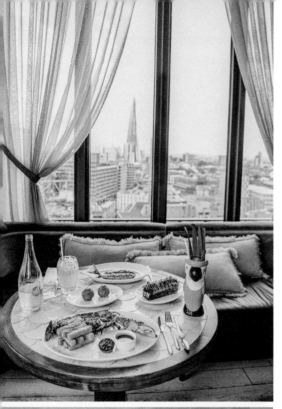

# Seabird at the Hoxton Hotel

## BOHO DESIGN, SEAFOOD AND A TERRACE YOU WON'T FORGET

🚇 Southwark

If you are in the mood for incredible views and seafood then Seabird is definitely where you should go. Perched on the fourteenth floor, on the rooftop of the Hoxton Hotel in Southwark, you will love everything about this place, from the boho decor to the incredible city views. Being high up, the light is beautiful and warm, turning it into the perfect summer dining destination. The Mediterranean-inspired menu offers fresh sea-to-table produce and if you like oysters, like we do, you will be happy to know Seabird boasts London's longest oyster list! So dig in, get yourself some oysters and a glass of wine and simply enjoy the beautiful surroundings. If you happen to be up there during the weekend, we totally recommend staying for brunch, they do an amazing grilled octopus roll, a mouth-watering crab and manchego omelette and a delicious manchego cheesecake. Another plus, the cocktails often come in cute parrot- and peacock-shaped cocktail glasses. Perfect for a fun picture!

📷 INSTAGRAM TIP

*For nice foodie pictures, the oyster platters look great on camera, does their brioche torrija. The table surfaces are also perfect for flat lays. When you book, ask for a table the outdoor roof terrace. It's beautiful in summertime, or if you prefer to sit inside, ask for a view of The Shard*

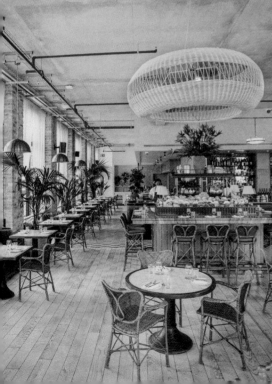

S
U
M
M
E
R

# A Day in Chiswick

⊖ Chiswick Park, Turnham Green

Chiswick is one of those neighbourhoods that everyone loves, with its little independent shops and cafés, only 30 minutes away from central London. It is the perfect mix of village and city and definitely makes for the perfect day trip.

One of the main reasons that drives Londoners to visit Chiswick during the summer is its position along the Thames and its large green spaces, which lend themselves to long walks along the river and picnics in the park. You can't go to Chiswick and not walk along Strand-on-the-Green, probably one of the prettiest streets in London, which always makes us jealous of the people living there. While there, we love to enjoy a Pimm's or a pint at the Bell and Crown, and wait for the tide to go out, revealing the closest thing you'll find to a beach in London.

If you have decided instead to spend the day sitting on a blanket in the park, then you may want to grab a book from one of the many bookstores in this neighbourhood. Our personal favourite is Foster Books, a family-run business based in the oldest shop on the Chiswick High Road, dating from the late

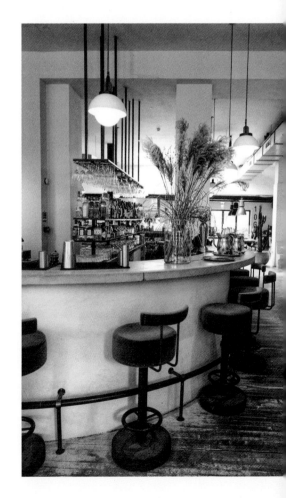

*This page:* No 197 Chiswick Fire Station is a restaurant with a picture-perfect interior. **Opposite:** Chiswick is full of independent shops. One of our favourites is Foster Books.

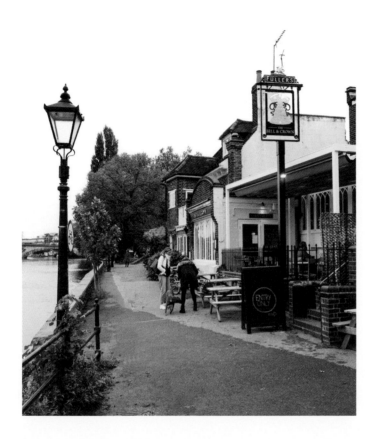

*This page: Enjoy a drink at the Bell and Crown whilst you wait for the tide to go out.*
*Opposite: The Mosaic House is a literal work of art. .*

eighteenth century. Here you will find antiquarian books, fine bindings, illustrated children's books and first editions, as well as many literary and art books. Also, have we mentioned that it is perfect for your Instagram feed?

Speaking of which, Chiswick features some of the most picture perfect restaurants in town. A special mention goes to No 197 Chiswick Fire Station, inspired by the old fire station that once stood on its location, and to Little Bird, a cute quirky cocktail lounge with Asian-inspired food and very creative cocktails, which can be enjoyed both inside and on their terrace.

Want to shoot something special? Then head to Mosaic House, a house you will definitely never forget. It's such a hidden gem that even some locals don't know about it. The artist, Carrie Reichardt, used her home as a canvas and some of the world's best mosaic artists contributed to this epic piece of art, which took over 20 years to complete.

Spending a day in a museum during summer might not, at first, be the most appealing of ideas, but the Victoria and Albert Museum, in the museum stretch of South Kensington, and its bright and airy galleries may just change your mind.

The V&A is the world's leading collection of art and design. It houses some huge collections, including post-classical sculpture, with the largest holding of Italian Renaissance items outside of Italy. In the 145 galleries, it showcases 5,000 years of art, from ancient times to the present day, from cultures all around the globe. It also holds an iconic costume and design collection, featuring over 3,500 items from every sector of the performing arts.

However, our favourite feature of the V&A is the John Madejski Garden, known to many as the heart of the V&A. Here – especially during the summer – thousands of visitors sit by the oval pool and enjoy the sunshine. The temporary exhibition here changes quite frequently, so anytime we visit the museum we love to go in the garden and check out what they have come up with. Alternatively, you can check the V&A website.

+ INSIDER TIP
~~~~~~~

The V&A Museum is walking distance from Kensington Gardens, so why not make it a day and also visit the Serpentine Gallery? The contemporary art there from globally emerging and established artists is exceptional!

Victoria and Albert Museum (V&A)

ITALIAN RENAISSANCE AND A GREAT COURTYARD

⊖ South Kensington

The Rooftop at
The Berkeley

PANORAMIC VIEWS AND
A SECRET GARDEN

⊖ Hyde Park Corner

With summer in full swing, there is no better place than a rooftop pool to enjoy some sun and cool down in the water. The Berkeley rooftop really has it all, with its panoramic views over Knightsbridge, impeccable design and the possibility of having a few bites from the healthy all-day spa menu. Or even a glass of wine – we absolutely won't judge. The pool itself is truly beautiful, from the mosaic tiling to the arched windows that frame Hyde Park, just on the hotel's doorstep. Truly picture perfect. If you feel like winding down after all this swimming, the Berkeley has one of the best spa's in town, and we can assure you that after a 30-minute back, neck and shoulders massage, you'll feel like you are relaxing peacefully in the countryside rather than in busy London.

What makes this rooftop truly special though is the secret garden near the pool, truly a little piece of heaven. There's nothing better than to relax on the sun loungers among lush plants and sweet-scented flowers when the weather is nice and warm. Every year, the team at The Berkeley does something new with this space, from an Italian Dolce Vita inspired oasis to a rooftop yoga retreat worthy of the best sun salutations.

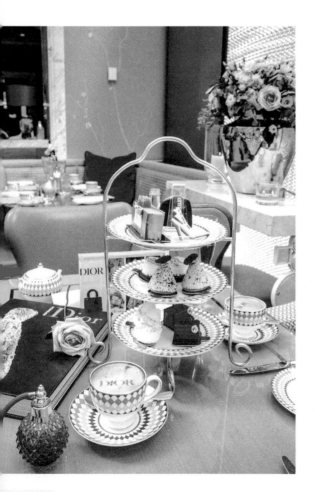

◉ INSTAGRAM TIP
〰〰〰〰〰

If you want to take your Insta-game to a whole new level, you should head downstairs and stop for afternoon tea, where you can sample the delicious and too-pretty-to-be-real Prêt-á-Portea, inspired by the most celebrated fashion icons and haute couture designers.

AUTUMN

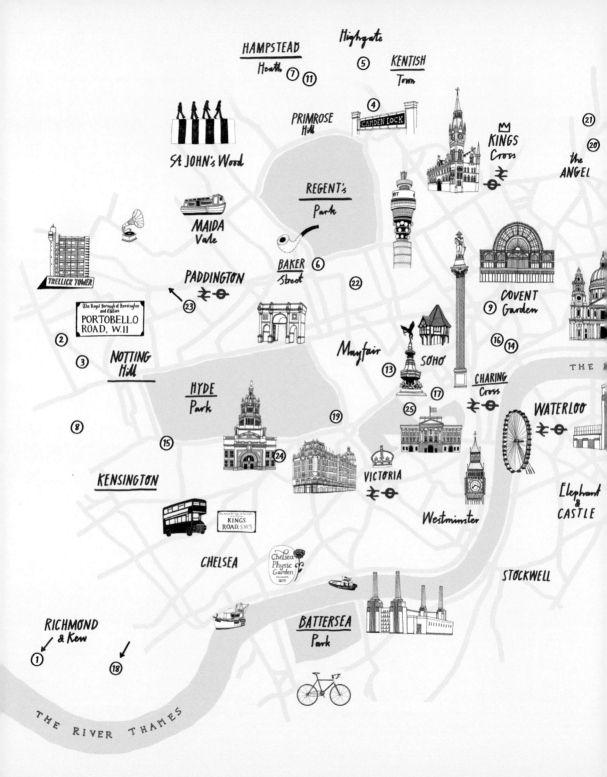

HAMPSTEAD
Heath

Highgate

⑤

KENTISH
Town

⑦ ⑪

PRIMROSE
Hill

④ CAMDEN LOCK

KINGS
Cross

㉑

㉒

the
ANGEL

St JOHN's Wood

REGENT's
Park

BT

MAIDA
Vale

BAKER
Street ⑥

PADDINGTON

The Royal Borough of Kensington
and Chelsea
PORTOBELLO
ROAD, W.11

㉓

TRELLICK TOWER

②

③

NOTTING
Hill

HYDE
Park

Mayfair

SOHO

COVENT
Garden ⑨

⑯ ⑭

㉒

CHARING
Cross

THE

⑧

⑮

⑲

⑬

⑰

㉕

WATERLOO

KENSINGTON

㉔

KINGS
ROAD, SW3

VICTORIA

Westminster

Elephant &
CASTLE

CHELSEA

Chelsea
Physic
Garden
FOUNDED
1673

STOCKWELL

RICHMOND
& Kew

①

BATTERSEA
Park

⑱

THE RIVER THAMES

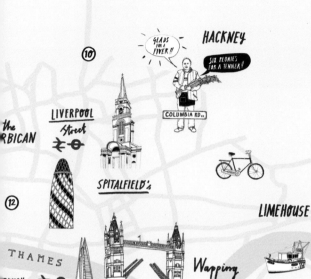

⑩

HACKNEY

GLADS FOR A FIVER!!

SIX PEONIES FOR A TENNER!!

COLUMBIA RD.

LIVERPOOL Street ⇌ ⊖

the RBICAN

⑫

SPITALFIELD's

LIMEHOUSE

Wapping

Rotherhithe

THAMES

ROUGH market ⇌ ⊖

LONDON Bridge

BERMONDSEY

Isle of DOGS

THE RIVER THAMES

The O₂

GREENWICH

THE RIVER THAMES

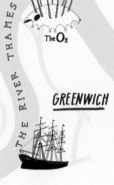

Richmond Park

ESCAPE TO LONDON'S LARGEST PARK FOR GREENERY AND WILDLIFE

⊖ Richmond

Summer may be over, but autumn in London can be truly spectacular. It's probably the best time of year for walking through the capital if you are looking for warm colours and misty mornings along the Thames.

The Royal Parks become particularly colourful during this time of year, with blankets of brown leaves on the ground and red ones still hanging the trees. That's why a visit to Richmond Park is a must, with its 2,500 acres of stunning autumnal-toned landscape.

Richmond Park is the largest of London's Royal Parks and one of its features is the wide variety of wildlife found here, the main attraction being the deer. Yep, you heard correctly! There are more than 650 deer roaming through the park, and they have been doing so for over 350 years. So bring your camera and all your lenses because you'll want to capture them from every possible angle. There are two species in the park, the Red Deer and the Fallow Deer. The Red Deer are typically bigger with large antlers, while the Fallow Deer are smaller with white spots. If you want to take a truly incredible landscape photo, we would recommend going first thing in the morning while the park is still misty.

Richmond Park is also one of the best places to go horse riding if that is your thing, so be sure to bring your riding boots and helmet if you are heading there for the day.

+ INSIDER TIP
〰〰〰〰〰

Another great season to visit the park is spring, as Isabella Plantation, the 40-acre woodland reserve, will be in full bloom. Here you will find magnolias and camelias, azaleas, large collections of rhododendrons and some very unusual trees. Also, spring is when the cute baby deer are born, but don't get too close or the mummies might become a little protective!

A
U
T
U
M
N

Portobello Road Market

BUSTLING ICONIC
ANTIQUES MARKET

⊖ Notting Hill Gate, Ladbroke Grove

INSIDER TIP

Portobello Road Market is bigger at the weekend, and Saturday is the busiest day of all. Try to go early – around 8am – when the market is still being set up to chat to vendors and have the stalls all to yourself.

Portobello Market, held on Portobello Road, is among one of the most iconic features of Notting Hill (see page 27), certainly it draws people from all over the world. Home to more than 1,000 stalls and vendors, selling almost anything you can think of, every day of the week, it stretches from Notting Hill Gate down to Ladbroke Grove. Our favourite section, the antique stalls, is located at the beginning of the market, near Notting Hill Gate station. We love getting lost there while looking for collectables for our home, and if you are lucky you may find a piece of Wedgwood!

As you walk down the market towards Lancaster Road, you will find the food section, with vibrant stalls piled high with fruit and vegetables, photogenic bread stalls, cheesemongers and other specialties. For your lunch break, stop at one of the many hot food and takeaway stalls, where you can eat everything from Caribbean delicacies to Indian curries – you'll be truly spoilt for choice.

The Westway area contains the 'fashion market', which features young new designers and also vintage clothing. Here, you can pick up collectables – you may even be able to find that vintage Burberry trench coat you've always dreamed about!

The section stretching from the Westway to Golborne Road contains the most eclectic variety of pre-owned goods. From childhood toys to first-edition comic books, we're sure you'll find something interesting.

Around the stalls, you'll find a variety of shops and cafés. One of our favourites, in the heart of the market, is the vintage store Alice's, an Instagrammer's milestone stop in Notting Hill. While the store front is great for a photo opp, inside you'll discover a range of curious objects, trinkets and wooden toys. Totally unique, these pieces are quite affordable, so they make perfect gifts or souvenirs.

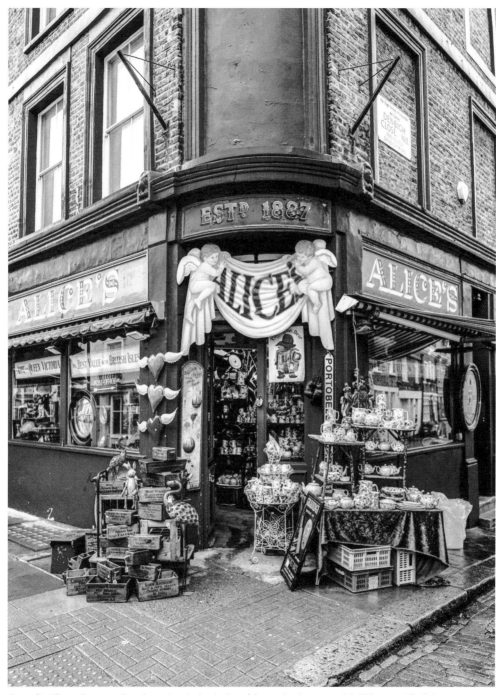

Opposite: The antiques section, situated at the beginning of the market, is a must-visit. **This page:** Alice's is an insta-famous store that sells unique curiosities.

Electric Cinema

UNIQUE CINEMA EXPERIENCE
IN A HISTORIC VENUE

⊖ Ladbroke Grove

Portobello Road is home to the iconic Electric Cinema. In service since 1911, it's an unmissable stop in the area and one of London's oldest cinemas. Now owned by the snazzy Soho House group, it's safe to say that this place is much more than a simple cinema. The interiors have been refurbished yet retain the best features of the original building. You'll find luxurious leather seats complete with footstools, cashmere blankets and bar staff delivering cocktails to your seat. Pick up your ticket in the old-fashioned foyer and choose from a curated list of movies. If this doesn't make for the perfect date, then we don't know what does! Add the chill or rain of an autumnal evening to make your evening all the more romantic as you snuggle up in a wing-backed armchair – or one of the front-row red velvet double beds. Yes, that's right, there are even six beds, which you can book in advance. Far more comfy than your own sofa, we guarantee.

+ INSIDER TIP

Next door is the American-style Electric Diner. If you get hungry before or after your screening we recommend stopping there. On weekdays, they usually have 50% off pre-cinema dinners from 5pm to 6pm. You just have to show your ticket!

Camden Market

ICONIC MARKET WITH STREET
FOOD, VINTAGE CLOTHING
AND UNIQUE FINDS.

⊖ Camden Town

If you are looking for vintage clothing, one-of-a-kind retail or something a little alternative, then Camden Market is the place you need to be. This retro market located near Camden Lock consists of a series of markets with around 200 stalls, where you can find deals on literally all sorts of stuff.

The most famous is probably Camden Lock Village, located by the Regent's Canal towpath, where you will find hip fashion clothing, food stalls with specialities from all over the world, and random home accessories that you'll find nowhere else in London. If instead you are looking for something a little more retro, the Stables Market is very 'boho' and you can find lots of retro furniture, vintage and even gothic clothing. Another market worth visiting is the Inverness Street Market, quite small compared to the other two, but here you'll find little stalls of fruit and vegetables.

Camden Market is vibrant, vivid and offers great Insta-photo opportunities, which are all perfect incentives to head there for the day with friends.

INSTAGRAM TIP

Camden High Street, with its independent, unique shops, pubs and restaurants, offers you ample photo opportunities. Be sure to check out the Camden Eye pub right by the tube station and Hartland Road with its stunning pastel-fronted houses.

AUTUMN

A Literary Tour of London

A WALK BACK IN TIME

⊖ Highgate, Archway, Baker Street

London has seen more than its fair share of poets and writers over the centuries, probably inspired by the world-class architecture, famous landmarks, hidden-away spots, stunning green spaces, canals and rivers, and iconic pubs. And that's still happening today – many artists, photographers and creatives of all sorts come to the capital in search of inspiration and like-minded people. If you like your literature and, like us, you love a good long walk, you will love this little literary walk we have put together for you. It will last around four hours, so it's probably best to do it after an early lunch so you can enjoy a pint on the way and either finish with a sunset view at Primrose Hill or dinner on Baker Street.

Walking words

Start your walk in Highgate, a quaint neighbourhood in north London that has seen many notable inhabitants over the years. Here you can go on a blue plaque hunt, among the eighteenth-century Georgian houses, where you will need to keep your eyes open for the names of Charles Dickens on North Road [1] and Samuel Taylor Coleridge [2] and J. B. Priestley [3] on The Grove (you may also bump into Jude Law or Robert Powell who are among the celebs who live there).

After Highgate, head towards Hampstead and pay a visit to John Keats's House on Nightingale Road.

Charles DICKENS

Samuel
TAYLOR COLERIDGE

①
②
③ J.B Priestly

⑤

HIGHGATE

HAMPSTEAD
Heath

KENTISH
Town

HOLLOWAY

HAMPSTEAD ④
John KEATS

⑧
⑥ ⑦

CAMDEN

PRIMROSE
Hill

W.B. Y YEATS

ST JOHN'S WOOD

REGENT's
Park

MARYLEBONE

BAKER ⑨
Street

⑩
Sherlock HOLMES

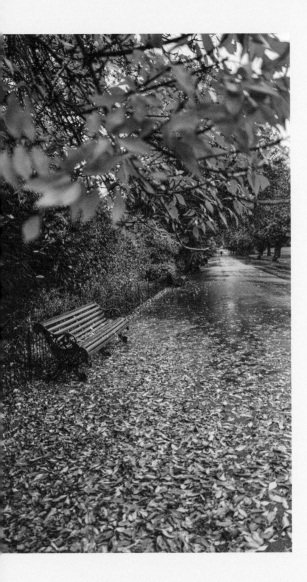

Stroll through Hampstead Heath, noting its beautiful autumn colours, which make the walk all the more picturesque. Keats's House [4] is today a poetry museum. You can sit and while away the time in its pretty gardens under the very tree that inspired 'Ode to a Nightingale'. If after all this walking, you fancy a pint, no worries. Head to the wood-panelled The Spaniards Inn, [5] one of the oldest and most iconic pubs in London. Charles Dickens immortalised it in The Pickwick Papers and Keats himself wrote a few odes here.

Next stop (if you haven't had too many beers that is!) is Primrose Hill (see page 94), around a 30-minute walk away. Here, among the colourful houses of Chalcot Square, [6] you'll find a blue plaque commemorating the American poet Sylvia Plath, and on Fitzroy Road you will find a plaque for Irish poet W. B. Yeats. [7] You will also want to climb up Primrose Hill (see page 94), which inspired poet and artist William Blake [8]. At its top, there's a stone edged with his words: 'I have conversed with the spiritual sun. I I saw him on Primrose Hill'. If you are feeling tired, you can watch the sun setting over the stunning panoramic view of London, visible from the hill. If not, you can carry on through Regent's Park towards 221b Baker Street, where Arthur Conan Doyle's fictional character, Sherlock Holmes [9], lived, now home to a museum dedicated to the iconic English detective, and end your day with drinks and dinner at the Holmes Hotel [10] in Chiltern Street (see page 130).

This page: The trees in Regent's Park are especially beautiful in Autumn. *Opposite:* Head to The Spaniards Inn for a pint, which has been immortalised by both Dickens and Keats.

Holmes Hotel

QUIRKY COCKTAILS,
STYLISH INTERIORS AND
PERFECT LOCATION

⊖ Baker Street

Whether you are a fan or not of the famous literary detective, Sherlock Holmes – the inspiration for this hotel – you will definitely love the Holmes. Situated in one of our favourite streets in London, trendy Chiltern Street, this hotel, with its Georgian heritage, is a true hidden gem.

Autumn is the perfect time to visit Baker Street, as it won't be too cold while you queue to visit the famous (and Insta-famous) Sherlock Holmes Museum at 221b Baker Street. And the moody weather will possibly put you into the shoes (or trench coat) of your favourite detective.

Apart from the hotel location and the atmosphere, the Kitchen at Holmes has amazing cocktails so autumn here is the perfect time to get cozy in the bar. We totally recommend ordering Sherlock's Pipe, which – hint – comes in a pipe-shaped glass. It's made with whisky, applewood-scented smoke and Negroni. Be camera ready for that scenic moment when the bartender unveils the drink!

+ INSIDER TIP
~~~~~~~

*The Holmes' location is extremely handy, not just for exploring nearby Baker Street but also its surroundings. Chiltern Street alone is worth a visit as a great foodie destination, think Chiltern Firehouse, Monocle Cafe and Fucina. And there's also lovely Marylebone Village, which features great shops, independent boutiques and pretty pubs.*

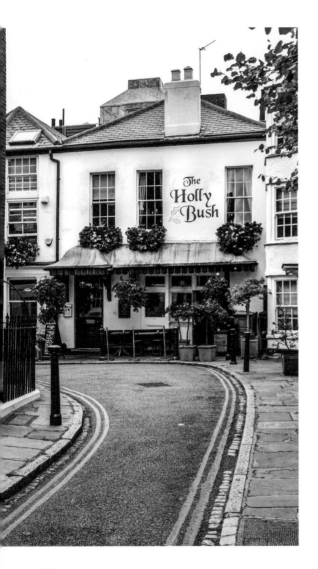

# The Holly Bush

HISTORIC 18TH CENTURY
PUB IN THE HEART OF
HAMPSTEAD

⊖ Hampstead

We think you'll agree with us when we say that The Holly Bush is one of the most charming pubs in the whole of London. From its quirky façade to centuries-old interiors, this historic pub in Hampstead will make you fall in love with it. Originally a residential house in the 1790s, it became a pub in 1928.

The wooden oak rooms and the dark brown stools at the bar counter are truly timeless – and this Grade II-listed building is definitely not short of cozy corners. And the best part is, it has a working fireplace inside, where you can warm up after an afternoon spent walking around Hampstead. While its position on a little hill gives the pub a village-like feel and makes for great photos.

The food is what you can expect from a traditional British pub – cheese boards, Sunday roasts and rich homemade desserts. Sound good? Then head to The Holly Bush, grab a drink and get toasty by the fire.

INSTAGRAM TIP

*This pub is also beautiful in the spring and summer months, when the flowers hanging from the upper floor windows are blooming. Grab a seat outside in the bench area or join the people standing outside with a glass of wine to soak up the sun. For the perfect picture, the trick is to head to the end of the cul-de-sac where you'll get a great angle of the pub.*

# Kyoto Garden

## A LITTLE BIT OF JAPAN IN LONDON

⊖ Holland Park

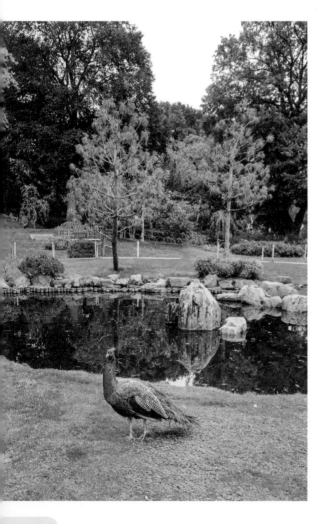

If you dream about long autumnal walks in red leaves, enjoying the bright colours of the season, then the Kyoto Garden in west London is the place for you! London is at its best at this time of the year generally, so head out, even though it can be tempting to spend your days indoors, snuggled up with a fireplace with a hot choc. Even though it does sound idyllic, grab your scarf, get a pumpkin spice latte along the way and get lost in the beauty of Holland Park, where the Kyoto Garden is nestled. We like to refer to it as a little slice of Japan in London. It's not such a surprise for a diverse city like London where unusual green spaces seem to be popping out of nowhere.

The Kyoto Garden was donated to the city by the Chamber of Commerce of Kyoto in 1991 as a symbol of the Japanese–British collaboration, and, well, we couldn't be happier that they did. The garden includes a picturesque waterfall, a pond with some koi carp swimming peacefully around and a selection of exotic trees native – you guessed it – to Japan. It can't really get more zen than this, right? During autumn, you'll see the edge of the Japanese maple trees turning gold and red, taking on the warm hues of the best sunsets. Oh, have we mentioned that you might even encounter a few majestic peacocks, while you are there, too?

+ INSIDER TIP
〰〰〰〰〰

*As with every Japanese garden worth its name, Kyoto Garden is home to some Sakura cherry blossoms. Head there in early spring to see the pink petals in action, the perfect addition to this relaxing haven.*

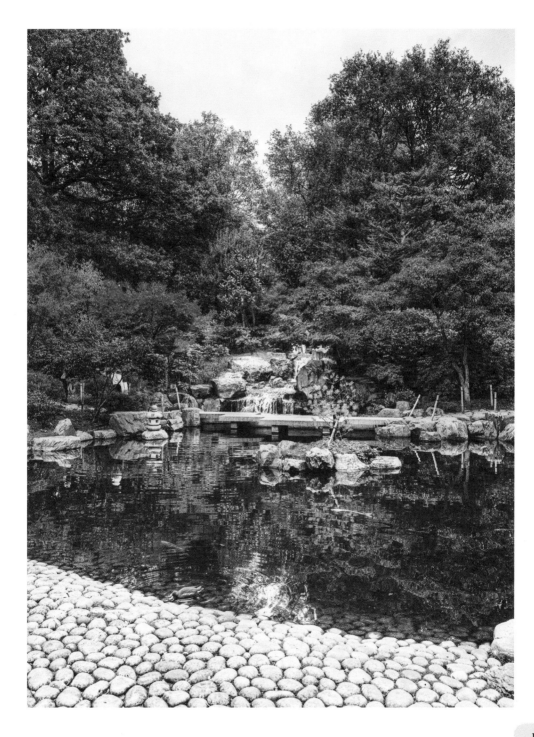

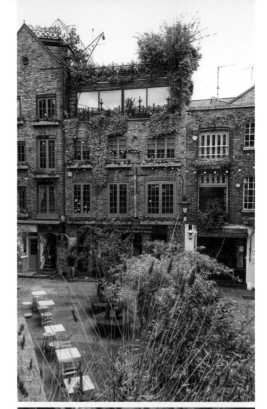

# Casanova & Daughters

### SICILIAN DELICACIES FOR THE LOVELIEST APERITIVO

⊖ Covent Garden

In recent years, Neal's Yard has become one of London's favourite gems. For us, it's almost impossible to walk by and not take a picture.

On one of those warm, sunny autumn days, we were craving a glass of wine and noticed Casanova & Daughters. This Italian deli was opened by Cedric Casanova, a former circus slack-rope walker. Casanova mainly works with small producers and simple, authentic and unique Italian products for his *aperitivo*, such as oregano from the mountains, pecorino, capers, tuna bresaola and specialist olive oils.

We know the weather in autumn can be quite moody, but if you decide to treat yourself to an Aperitivo Sicialiano and the sun isn't shining to make it terrace weather, you can always sit inside at the long convivial table upstairs and sample some of Casanova & Daughter's stunning antipasti.

+ INSIDER TIP
〜〜〜〜〜

*Neal's Yard is like a mini village, full of interesting shops, cafés and bars. We recommend going for a 20-inch pizza at nearby Homeslice Pizza, Neal's Yard Dairy for their incredible selection of cheeses and 26 Grains for brunch.*

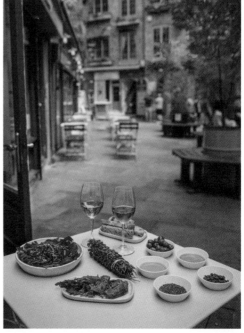

*Oh, those cardamom buns ...!*

If you've uttered those words when thinking about Fabrique Bakery, don't worry. You are not alone.

Fabrique is an artisanal stone-oven bakery with its origins in Stockholm and multiple branches now in London. It uses fresh, natural ingredients to make the best bread and cinnamon buns in town. Fabrique has been so popular in recent years that there are now six shops across the capital, all of them very photogenic. Our favourite has to be the one in Hoxton, east London. Set in a railway arch next to Hoxton railway station, this shop was the first to open and is where all the magic happens. All the baking is done here and you can witness the whole process, which will make it almost impossible not to indulge in one of their straight-out-of-the-oven pastries or loaves.

The Hoxton shop tends to be kind of hipster-ish, but without putting too much effort into trying to be so. The inside is pretty small, but if you manage to find a seat it is super cosy.

⊙ INSTAGRAM TIP
〰〰〰〰〰〰

*If you are looking to take that perfect coffee-table shot, then head to the branch in High Holborn. It has the perfect lighting, pretty tables and the cosiest atmosphere.*

# Fabrique Bakery

THE BEST CINNAMON BUNS
IN LONDON

⊖ Hoxton

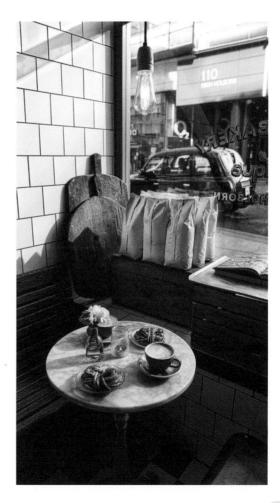

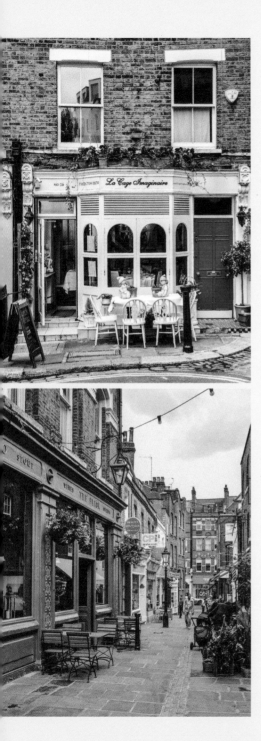

# A Stroll in Hampstead

PICTURESQUE LEAFY NEIGHBOURHOOD

⊖ Hampstead

> If you ask Londoners what their favourite neighbourhood in the capital is, many will answer Hampstead. This pretty place has its own magic and it makes you feel as if you're 1,000 miles from London. It has a village feel like no other area of the capital and it is absolutely perfect if you want to switch off or go for a Sunday stroll.

During autumn, Hampstead is particularly picturesque. The old houses with their colourful front doors are covered in red leaves and there are lots of pubs and cafés you can seek shelter in if it gets chilly. There are some truly stunning leafy streets to wander through and small cobbled streets, such as Flask Walk, where you can find antiques and florist shops, and Perrin's Court, with its picture perfect houses.

If you love red leaf-covered houses, then Hampstead is a treat. Each time we go, we discover a new one, which is a great incentive to keep going back. You should visit towards the beginning of October and, after a walk through the cobbled streets, head towards Windmill Hill, stopping on the way at The Holly Bush pub (see page 131). We would also recommend finishing your day with a walk in Hampstead Heath, the park that helped inspire C. S. Lewis's Narnia!

*This page top and bottom: Flask Walk with its pretty cobbled streets. Opposite: This house on Fitzjohn's Avenue, covered in red leaves, is pretty special. If you're lucky, a vintage car will be parked right in front of it making it, picture perfect.*

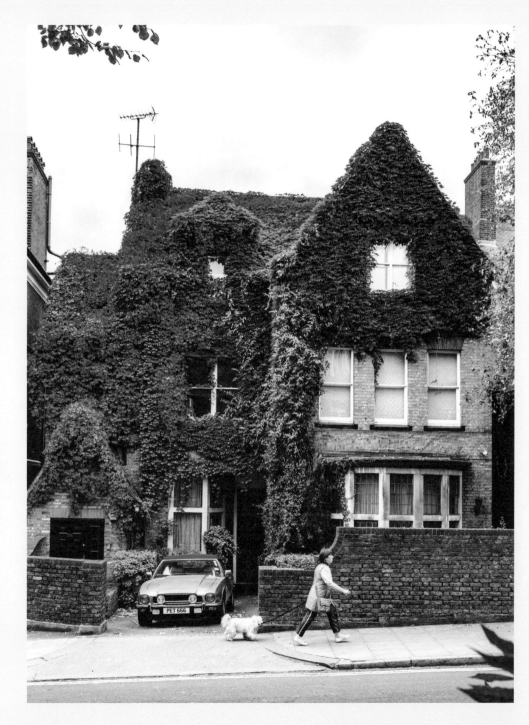

# Host Café

COFFEE AND CAKES IN A
GOTHIC CHURCH BUILDING

⬥ Mansion House

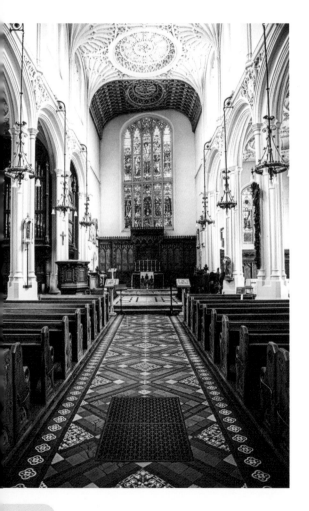

As we know that unusual spots are totally your jam, we couldn't not include Host Café in this book. If having a cappuccino in a historic church sounds good to you, then keep reading! Believe it or not, Host is located in one of the oldest churches in the city, Saint Mary Aldermary. The church fared badly in the Great Fire of London of 1666, but was restored in the late seventeenth century by Sir Christopher Wren, the genius behind our beloved St Paul's Cathedral. With its vaulted ceilings and distinctive Gothic-style columns, Host provides the perfect quiet and reflective space for customers to take a break from the city. Great if you are looking for somewhere peaceful to relax with a nice cup of coffee after a busy day wandering around London.

The coffee is provided by local roasters, while the breads come from The Artisan Bakery and the pastries arrive directly from Bermondsey-based Little Bread Pedlar. If you are looking for something hot to eat, the café also serves organic soups and yummy sourdough sandwiches, but you can also bring your own lunch and just sit in reflection. Words cannot *espresso* how much we like this place.

+ INSIDER TIP
〰〰〰〰

*Nearby is the Monument, also designed by Wren, which was built to commemorate the Great Fire. Not many people know that you can climb 311 steps up to its viewing platform. The panorama is truly amazing and you even get a certificate for the climb!*

# Moncks

If there is one reason to visit Monck's bar and restaurant, located on the site of the former Clarendon Estate in Mayfair, and named after its last aristocratic owner, Christopher Monck, it's for their incredible Truffle Mac & Cheese. A gratinated deliciousness of cheese and Perigord black truffle, it's totally worth the calories and great for when you fancy something hearty on colder days. Everything is to love about Moncks – from its great location to the impeccable service, which is spraised by its many returning guests. On a rainy day, Moncks will provide you with a stylish shelter but will also brighten up your day with its gorgeous decor. The accents of colour, the Art Deco styling and the luminous spaces will put a smile on your face on an otherwise grey day. There is also a nice little garden at the back, facing the dining hall. How lovely is that?

+ INSIDER TIP

*Moncks's menu honours timeless classic dishes, made using the finest and freshest products, all with a modern European twist. Highlights include burrata with pine nuts, confit cherry tomatoes and rocket pesto, and the scallop gratin, which is served inside a real shell. Oh so simple, but oh so delicious!*

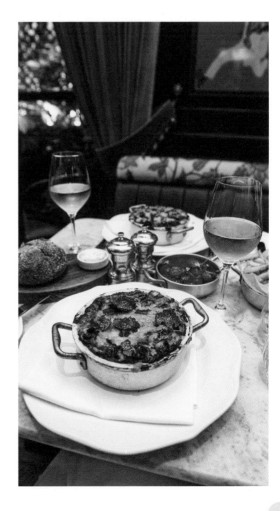

# The Savoy Hotel

## LUXURY, CITY VIEWS
## AND GLAMOUR

⊖ Temple

Among London's iconic hotels, The Savoy is one of the snazziest and most beautiful. Opened in 1889, The Savoy is also the only luxury hotel located on the River Thames. The first hotel of its kind in London, The Savoy's reputation for comfort and service made it a true magnet for the rich and famous. Among its notable guests you'll find Harry S. Truman, 33rd President of the United States, Charlie Chaplin, Marilyn Monroe and The Beatles. Ah, if those walls could talk!

But now you must be wondering, what makes The Savoy so special during autumn? Well, the beautiful interior and incredibly welcoming staff will make you feel so cozy that if you encounter some rainy days in London, you may easily spend all your afternoons tucked up inside.

Highlights of the hotel include the legendary American Bar, where you can get comfy while listening to the incredible in-house pianist working his way through the best of American jazz. Needless to say, the drinks menu is excellent and each cocktail name refers to a memorable line in the song from which it takes its inspiration. Unmissable on a rainy day is also the Savoy's world-famous afternoon tea, which is set in the beautiful Thames Foyer. The centred glass dome is a showstopper and soft live music plays, while you work your way through pastries and delicate finger sandwiches. And maybe a glass of champagne or two!

○ INSTAGRAM TIP

*If you're looking for a room with a view, start your search from the Luxury King category onwards. These rooms overlook the Thames. Once inside, expect unbeaten panoramic views over the Southbank and on to some of London's most significant landmarks. All, of course, framed by the most idyllic autumnal setting of crisp red–brown leaves and misty skies.*

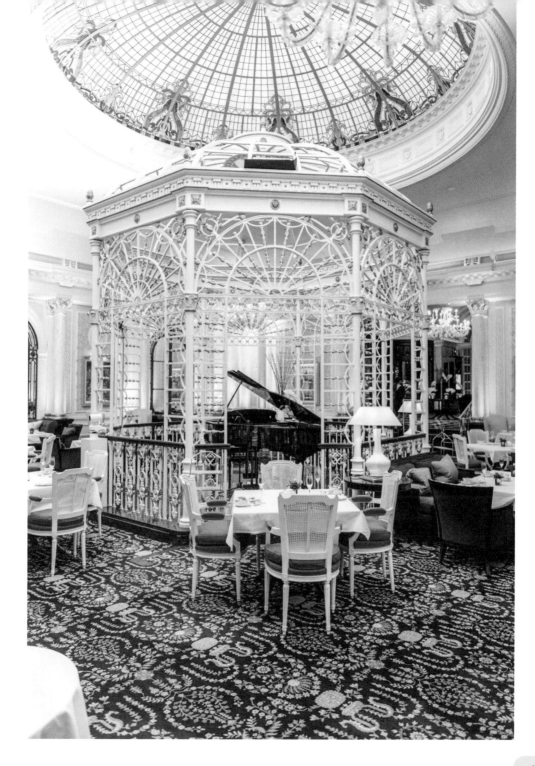

# Stables Bar at The Milestone Hotel

SIT BACK AND ENJOY A DRINK,
EITHER TRADITIONAL
OR WITH A TWIST

⊖ High Street Kensington

A secret little spot in west London, the Stables Bar is snuggled inside the iconic Milestone Hotel. While the hotel is stunning, set in a seventeenth-century Grade ll-listed building, this lounge bar will take you back in time, making you feel like you are in another era! It is also the perfect hideaway, a place to take shelter from the autumnal chill with a cocktail or two. We particularly love the unique design of this bar, which as the name Stables suggests, pays homage to horse-racing history. With beautiful paintings and rich green leather armchairs, the bar has other little touches such as equestrian statues and themed pillows that really set it apart. From the drinks menu, we recommend their signature cocktail, the Smoking Old Fashioned, which follows the traditional New Orleans recipe, but with a special twist at the beginning, followed by something theatrical at the end. We won't reveal more! If you fancy a talk with the knowledgeable and friendly barmen, sit at the mahogany bar and they will make sure to find something to your taste. The savoury nibbles and snacks from the bar menu are excellent; we love the wild mushroom arancini and the kataifi-wrapped prawns with guacamole mayonnaise.

+ INSIDER TIP

*The Milestone Hotel offers a guided tour of the iconic Royal Albert Hall, located just 10 minutes' walk away. You can learn all about the stage that has been walked on by the likes of Muhammad Ali, Madonna and Winston Churchill.*

# Henrietta Bistro

QUIRKY COCKTAILS AND
MEDITERRANEAN FOOD IN THE
HEART OF COVENT GARDEN

⊖ Covent Garden

Henrietta Bistro is a small and elegant dining room; which is part of the boutique Henrietta Hotel in Covent Garden. It is light and airy, has a little bit of a rustic feel and is perfect for escaping the crowds of this bustling part of London.

The menu at Henrietta Bistro is Mediterranean and inspired by south-west France, Corsica and the Basque country, with wines from both small growers and larger producers, all at a reasonable price.

The concept here is sharing plates, a way of dining that we love, as it gives you the opportunity to sample a lot of dishes. We suggest ordering 3–4 plates each, which will be served to you as soon as they are ready. Everything we have tasted has been delicious, but a dish that is an absolute must is the burrata with freeze-dried strawberries and basil, a delight both for the palate and to the eyes. Also, the decadent warm chocolate mousse with the smokey whisky ice cream is a must.

If you have already dined elsewhere and just fancy a drink or some cocktails, you can enjoy them at the mezzanine bar, which is a quirky menu inspired by the hotel and the neighbourhood's rich past.

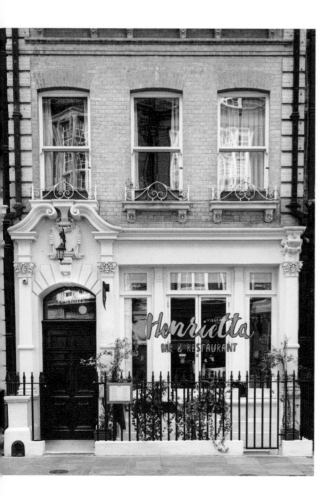

+ INSIDER TIP
〜〜〜〜〜

*Covent Garden always goes over the top when it comes to Halloween, so why not visit when the decorations are up? We never know what they will come up with, but it often involves giant pumpkins!*

AUTUMN

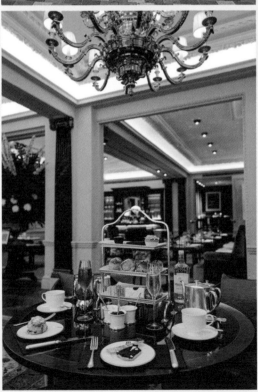

# A Foodie Day in St James's

SOME OF THE BEST RESTAURANTS AND BARS ALL
IN ONE NEIGHBORHOOD

⊖ Green Park

Everyone who has visited or lives in London has walked at least once through the beautiful streets of St James's, with its many art galleries, independent quirky shops on Jermyn Street and, of course, St James's Park. However, very few know that this area has also become a foodie destination, so here are some of our favourite places that will help you stay away from the usual chain restaurants and tourist traps.

When it comes to breakfast, our go-to place is Ole & Steen, a Danish bakery serving all sorts of delicious homemade breads, pastries, coffees and cakes. Their team of bakers starts baking at 10pm and bakes right through the night so that all the food is fresh in the morning. If instead you've spent the morning shopping and it's now time for lunch, we recommend paying a visit to 45 Jermyn Street, part of Fortnum & Mason (see page 175). The interiors are super-chic, the food is delicious and it is mainly popular with locals, so no noisy tourists to disrupt your dining experience. If you still fancy visiting Fortnum & Mason but don't want to stop for lunch, you can always head to The Parlour on the first floor of the prestigious department store for the best white chocolate in town.

St James's also has a fantastic cocktail scene, and on a nice day we can definitely recommend drinks with a view on the rooftop at The Trafalgar Hotel, St James's. If it's one of those gloomy autumn afternoons though, then head to Dukes Bar, a legendary cocktail bar said to have inspired James Bond's signature martini. If, after a few drinks, you're feeling a bit hungry, you will be pleased to hear that our favourite pizza place in London is in St James's (trust us, we are Italian and we know our pizza). 'O ver makes the tastiest wood-fired pizzas, fresh pasta, homemade breads, Neapolitan street food and handmade traditional desserts. They make all this using pure sea water, the first restaurant in the UK to do so.

If you are looking for a tranquil spot for a short break, then you should visit the courtyard of St James's Church Piccadilly, where you will also find a little market with its own special atmosphere. You can either sit in the courtyard, browse around for gifts or look around the little church built by Sir Christopher Wren, architect of St Paul's Cathedral.

Last but not least, if you feel like getting cosy after a walk in St James's Park, we would recommend afternoon tea at The Stafford hotel. Very well hidden, tucked away in the heart of St James's, the hotel gets very creative with its pastries, some inspired by the surrounding boutiques and galleries.

# Pumpkin Picking Patch Wimbledon

BECAUSE IT'S NOT REALLY HALLOWEEN WITHOUT PUMPKIN CARVING

⊖ Wimbledon Park

With autumn in full swing and pumpkin season upon us, there is no better activity than pumpkin picking! While there are many great patches in the countryside to find your perfect pumpkin to carve, it isn't easy to find one in London. The Pumpkin Picking Patch at Wimbledon is one of the few. It is easy to find, located just off Wimbledon Park Road, opposite Centre Court. Usually open from the middle of October and, other than pick-your-own pumpkin, it also has great activities, including pumpkin games, animal straw sculpture, and a pumpkin house and garden (inhabited by witches, of course). So, put on your favourite pair of boots, borrow a wheelbarrow and fill it with pumpkins for some fun autumnal pictures. We are sure you'll find that special pumpkin to take home with you and decorate just in time for Halloween. Once you're done roaming the patch, head to their onsite Pumpkin Café for a bite of their organic selection of food.

+ INSIDER TIP
~~~~~~~

Pumpkins are not only great for Halloween decorations or picture props but they are also wonderful for delicious autumnal recipes. One of our favourites is the pumpkin fondue – and you can find the recipe, on their website.

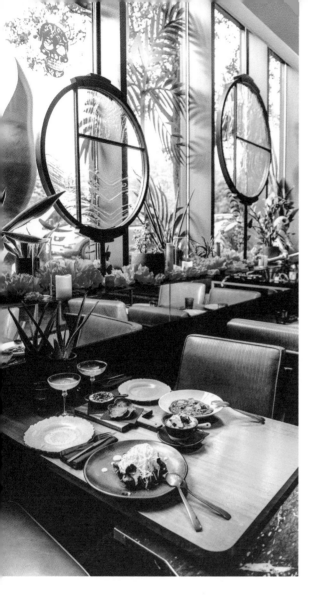

Ella Canta

MARGARITAS AND TACOS
BUT MAKE IT ARTSY

⊖ Hyde Park Corner

Ella Canta is a Mexican restaurant in Mayfair owned by world famous chef, Martha Ortiz. This gem in Mayfair is inspired by Mexico's iconic culture and history, with dishes that are created from the blending of ancient traditional cooking with a contemporary touch, all this in an atmosphere that will get you in the mood for a good time.

Ortiz is extremely passionate about creating highly artistic and colourful dishes – all her creations are both delicious and a treat for the eyes. The ingredients are imported from Mexico where possible, so things like tortillas and tacos are made with Mexican corn.

Although Ella Canta is always worth visiting, whatever the occasion, we absolutely love the show they put on for the Día de los Muertos (Day of the Dead) on 2 November, with *calaveras*, aztec marigolds, skeletons and – of course – loads of margaritas. They always create a special menu for this day that is so important in Mexico, so we would recommend heading there with a group of friends and checking it out.

+ INSIDER TIP

If you love Mexican food, then you'll appreciate the menu. There is a dish that is an absolute must: the huevos con mole negro. The mole sauce recipe dates back to the sixteenth century and is made with 50 different ingredients. Also worth mentioning are the churros, which come with a dip that is to die for.

Camden Passage

A QUAINT HIDDEN STREET IN ISLINGTON WITH ANTIQUE
STALLS AND INDEPENDENT BOUTIQUES

⊖ Angel

Camden Passage is a picturesque cobbled back street in Islington, filled with antique shops, great brunch spots and trendy cafés. This little passage is just off Upper Street in north London and is packed with locals all week long, who are either shopping for food at the specialist delicatessens, catching up with friends over coffee or buying unique clothing and homeware from the boutiques.

This corner of Islington is particularly charming, as it is quite vibrant and almost tourist free. It is a great place to find inspiration, so if you are looking for that perfect gift or want to treat yourself to a unique piece of jewellery, then you are in the right place. Usually, where there are vintage shops there is also a market, and Camden Passage is no exception. Running every Wednesday and Saturday, you will find lots of Art Deco and retro objects, all sourced by the traders who put a lot of effort into finding interesting pieces. It is not too crowded so you won't have to speed through the stalls, making the experience quite pleasant, even if you don't end up buying anything.

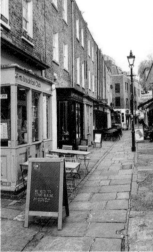

INSTAGRAM TIP

There are lots of cafés and restaurants, but we always seem to end up in Brother Marcus. The wooden interiors, the buzzing atmosphere and beautifully presented and very tasty food make this place a fantastic spot for breakfast or brunch. If you want to take the perfect picture, reserve a seat by the window, as you will have great natural light and the cobbled passage as a background for your shot.

AUTUMN

The Humble Grape

THE PERFECT PLACE TO COSY
UP WITH A GLASS OF WINE

Angel (our favourite branch)

We know what you are thinking, it's a chilly late-autumn evening and you feel like having a glass of wine in a nice snug place. Well, rest assured, we have you covered. The Humble Grape is an independent collection of wine bars scattered all around town, in Battersea, Fleet Street, Canary Wharf, Islington and Liverpool Street, so you'll be almost sure to find one in whatever part of London you're in. They specialise in importing artisan wines, all from single vineyards, that are largely organic, biodynamic and sustainable. Most have cute little stories behind them, coming from family producers, so make sure to ask your waiter if they can tell you something more about the wine you are choosing. Their wine list has some 400 wines, but, as many of the ones they collect are small-batched, the lists are updated quite frequently. Better stock up if you find one you like!

Our favourite location is in Islington. Here they have a leafy dining room, a wine bar and even a 'wine library', where you can flick through a curated collection of books on the subject from all around the world. We particularly love the rustic setting of the room at the entrance and our favourite spot is the bench by the window. And, as if it couldn't get any better, the food is truly great. Recommended are the taleggio and pea arancini, the burrata, and the honey and hazelnut baked camembert.

+ INSIDER TIP

Check out their website for special offers. On 'Retail Mondays', the price of a bottle of wine at the bar is the same as if you were buying it to take away. On 'Iconic Wine Thursdays and Fridays', you can buy wines usually sold only by the bottle, by the glass. In the Islington and Battersea locations, on Wednesdays, you can drink, while listening to live jazz.

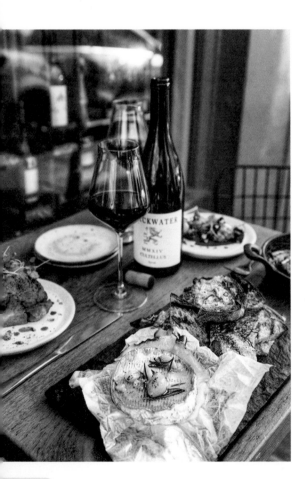

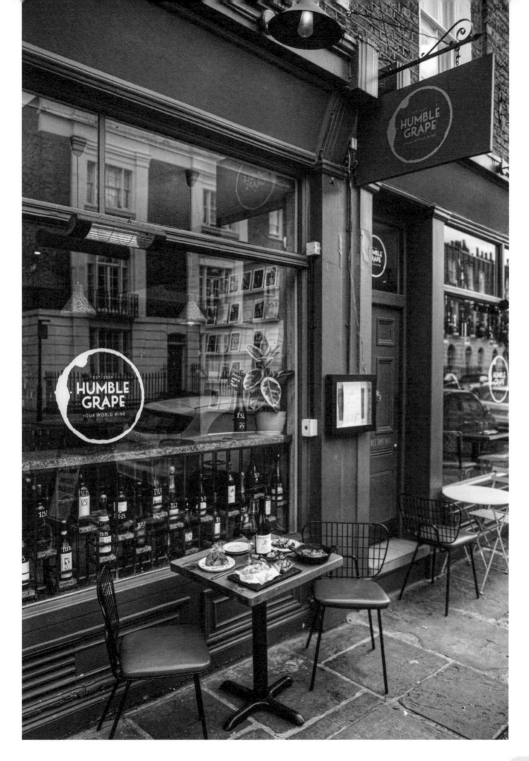

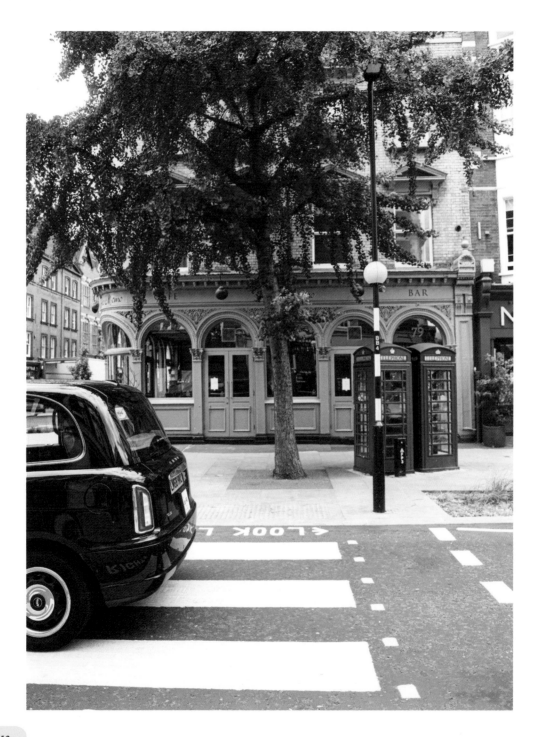

Nestled between the green expanse of Regent's Park and the hustle and bustle of Oxford Street, Marylebone Village is a quiet little neighbourhood that tourists don't seem to have discovered yet. Thanks to its boutiques, independent shops and restaurants, cafés and charm, this area of London is among our favourites and we always seem to find an excuse to visit.

Marylebone Village has everything it needs to give you that elegant town feel, with photo opportunities around every corner and lucky locals enjoying their beautiful neighbourhood. A place we always seem to be drawn to is Daunt Books, a stunning bookshop with Edwardian touches and long rows of oak bookcases that will just make you fall in love with it. We have never walked out of Daunt Books without acquiring something new for our home library.

Our main reason for heading to this part of town though is the many foodie options it has to offer. If you are looking for the perfect breakfast spot, then definitely head to La Brasseria Milanese, gorgeous from the outside and serving great Italian food. For brunch, we love dining at the 108 Brasserie, at the top of Marylebone Lane, an elegant brasserie and bar that's part of The Marylebone hotel, which serves seasonal dishes inspired by culinary delights from across the globe.

Our favourite lunch spots are Fischer's, a restaurant that serves Austrian food in an ambiance inspired by early twentieth-century Vienna, and A.O.K. Kitchen, which serves healthy Mediterranean food in a unique setting. For dinner, if you are into Japanese food and would like to be virtually transported to Tokyo, then you should definitely try Taka. If instead you fancy a roast – even a veggie one – our favourite pub is The Coach Makers Arms.

Marylebone Village

CHIC NEIGHBORHOOD WITH A LOCAL FEEL

⊖ Baker Street

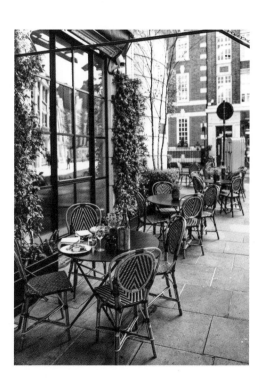

+ INSIDER TIP

Like every village worthy of its name, Marylebone Village has its own Farmers' Market on Aybrook Street, open from 10am to 2pm, every Sunday, where you can find lots of organic produce and home grown ingredients.

AUTUMN

A Day Trip to the Cotswolds

IDYLLIC COUNTRYSIDE VILLAGES

🚉 Paddington → Chippenham (for Castle Combe), Kemble (for Bibury),
Moreton-in-Marsh (for Bourton-on-the-Water)

You can't get more English countryside than in the Cotswolds. This idyllic part of the UK, with its rolling hills, has one of the most picturesque rural settings in the world, a place that anyone living in Britain or visiting it should go to at least once in their life.

The Cotswolds stretches over an area of almost 800 miles and extends over several English counties – mainly Gloucestershire and Oxfordshire but also Wiltshire, Warwickshire, Worcestershire and Somerset. It has been declared an Area of Outstanding Natural Beauty due to its diverse wildlife, ancient beech woodlands and limestone grasslands. For us, a visit to the area is the perfect autumnal day trip from London.

Our favourite way of reaching the Cotswolds is by car, as you have the freedom to visit as many small towns as you like. It's also the quickest way to get there. If you don't own a car, we would suggest renting one outside central London, in Watford, for example, so you won't risk getting stuck in traffic.

There are hundreds of small villages worth visiting in the Cotswolds, but one we always seem to be drawn to is Castle Combe, in Wiltshire. Does this name ring a bell? It's probably because 'The Prettiest Village in England', which looks like a picturesque movie set, has become an Instagram sensation. We usually make this our first stop so that we can

beat the crowds, plus – if we are lucky – we can still experience that morning mist that makes everything seem a little spooky. We can guarantee that it will be love at first sight when you visit – with the limestone cottages, beautiful floral hanging baskets and landscape strewn with gold and red leaves.

Our next stop is usually the tiny village of Bibury, in Gloucestershire, once described by texture William Morris as the most beautiful village in England. Here we like to photograph the idyllic Arlington Row, built in the fourteenth century and the most famous little street in the Cotswolds. As mentioned, the town is small so you will probably not spend more than a few hours here. Also, worth a tour is Trout Farm, which only costs a few pounds to enter and is one of England's oldest working farms. If you feel really keen, you can always fish your own trout for supper!

Our next stop, before heading back to London, only a 20-minute drive from Bibury, is Bourton-on-the-Water, also known as the 'Venice of the Cotswolds'. Here you will see pretty little bridges that cross the River Windrush, that runs through the centre of the village. There are also lots of tearooms, pubs and cafés if you fancy a break after driving.

Opposite: Castle Combe is a picture-perfect village in Wiltshire.

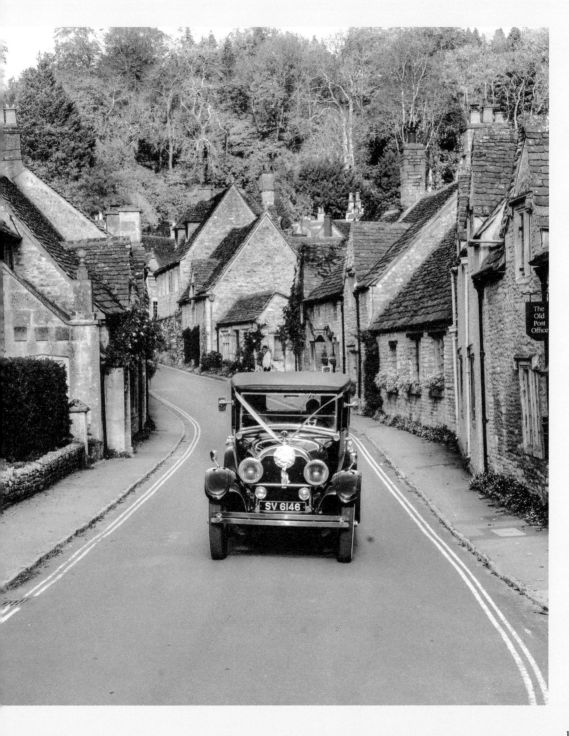

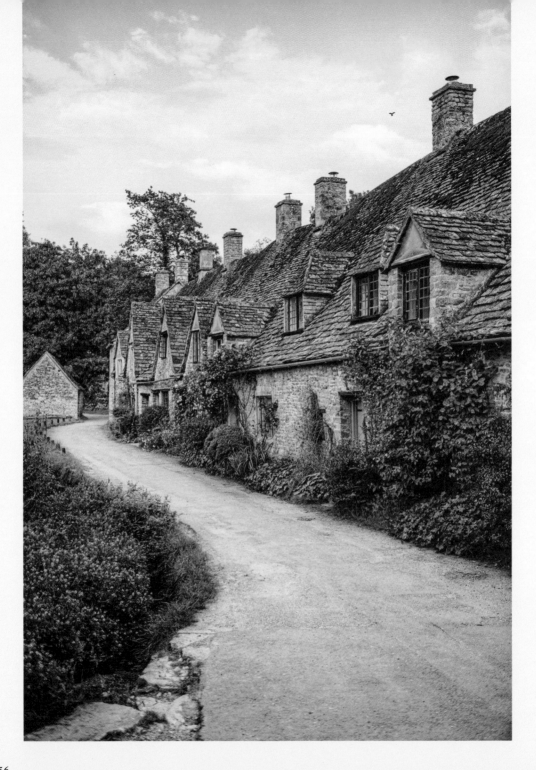

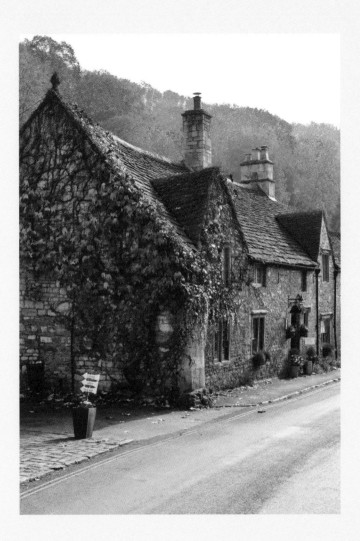

There are plenty of charming villages, picturesque landscapes and quaint cottages in the Cotswolds, so although we suggest visiting the ones above at some point, there are many more that we are sure you will love. We have spoken to some locals during our day trips there and they have suggested Burford, Broadway, Chipping Camden, Stow-on-the-Wold and Lechlade-on-Thames. These are now next on our list – maybe you'll be able to check them out before us!

This page: You'll be sure to fall in love with the quaint sandstone cottages. *Opposite:* Arlington Row in Bibury is possibly the most famous street in the Cotswolds.

The Franklin London

A GLAMOROUS BUT COSY BOUTIQUE HOTEL

⊖ South Kensington, Knightsbridge

The Franklin hotel is located in a stunning row of Victorian buildings and manages to combine the hospitality of a private home with the service of a luxury hotel. This elegant hotel is located between Knightsbridge and South Kensington and is very well hidden, perfect if you are looking to stay in central London but on a quiet street away from the hustle and bustle of everyday life.

The Franklin has some of the prettiest views over the lovely Egerton Gardens, but this isn't the hotel's only highlight. With its mirrored walls and 1920s Great Gatsby-esque style, The Franklin Bar is a perfect place to relax and enjoy some delicious classic and signature cocktails. Also, if you are a big gin fan, this is definitely the place for you, as the bar boasts 22 different varieties.

A stop at the bar will definitely get you in the right mood for what is now considered to be an essential foodie destination in London – The Franklin Restaurant. Here you can taste chef Alfredo Russo's superb Italian-inspired food. He creates simple but unusual dishes, our favourite of which is the Passato di verdura, a very colourful vegetable soup made with over 18 seasonal vegetables. All this in a charming, glamorous and central setting.

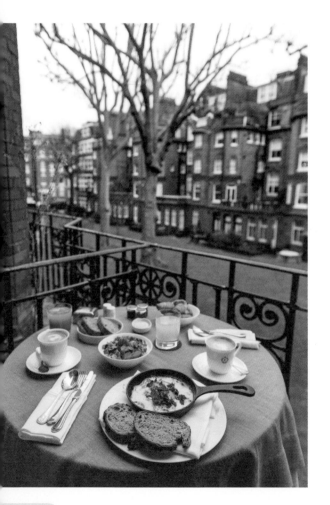

+ INSIDER TIP

The Franklin is conveniently located close to many unmissable London museums such as the Natural History Museum and the Victoria & Albert Museum (see pages 112 and 174).

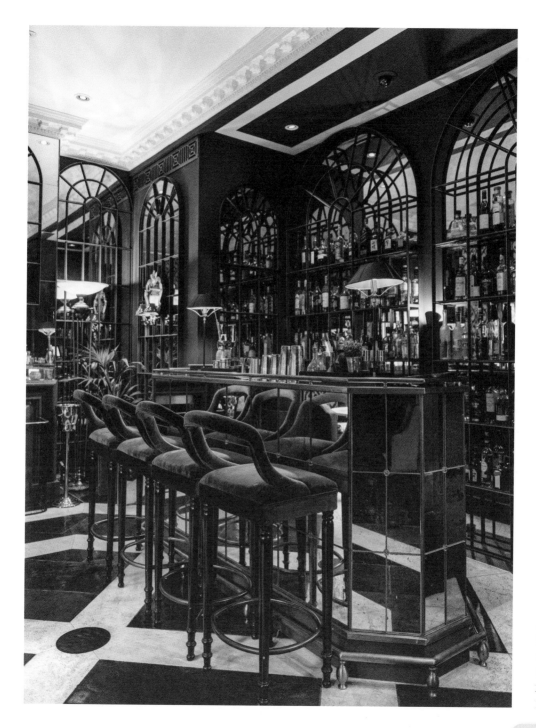

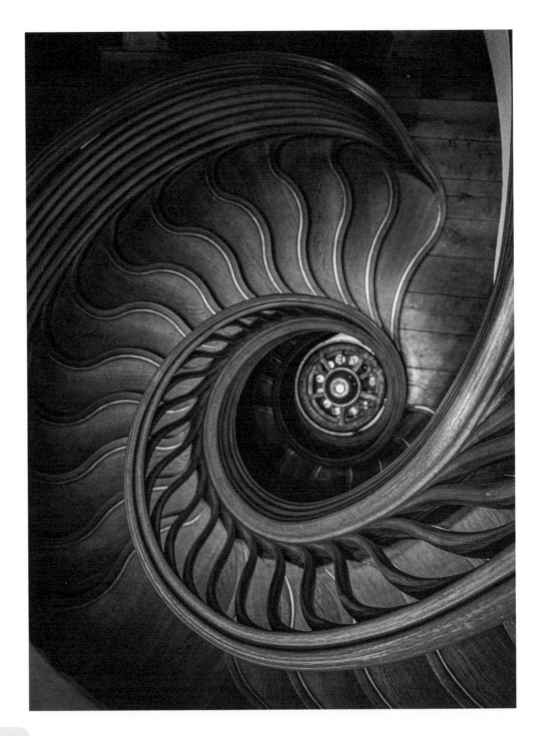

Set over three floors, Hide is the perfect dining destination for an autumnal day in London. As the name probably suggests, this restaurant is quite hidden but in a grandiose sort of way. What does that mean, you may ask? Well, Hide is big, and even though it's located on one of the busiest streets that links Green Park to Piccadilly, its entrance is subtle and perfectly blended in with its surroundings. You might even walk by without noticing the restaurant at all. Once you step inside, you will see a surprising space filled with natural light and a hearty colour palette that totally reminds us of autumn. It seems like all three floors are made out of beautifully worked wood.

Get a spot by the windows on the formal and elegant 'Above' to enjoy the beautiful views over Hyde Park, or in the more casual 'Ground' to watch all the stylish people walk by. After dinner, head to 'Below' for perfectly created cocktails by some of the greatest mixologists around. Wherever you decide to sit, the dishes are beautifully presented and even the breadbasket looks like a work of art.

Needless to say, Hide landed itself a Michelin star within a year of opening. Pretty impressive, right? During autumn, they often create season-inspired dishes, including a pumpkin soup and a creative autumnal pasta. One last thing, if you stop in for breakfast or brunch, you have to try their truffled scrambled eggs on toast. Absolutely divine.

Hide

BE SURPRISED BY CREATIVE SEASONAL DISHES

⊖ Green Park

INSTAGRAM TIP

Head up to the 'Above' level and take an Insta-worthy picture looking down on the grand oak spiral staircase that connects all three floors. Truly beautiful and the colours will look perfect on your autumnal feed.

161

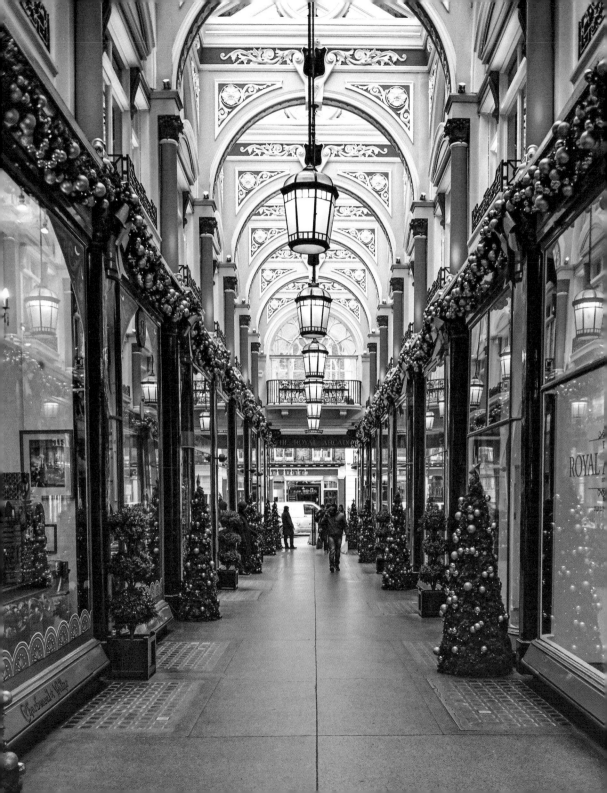

WINTER

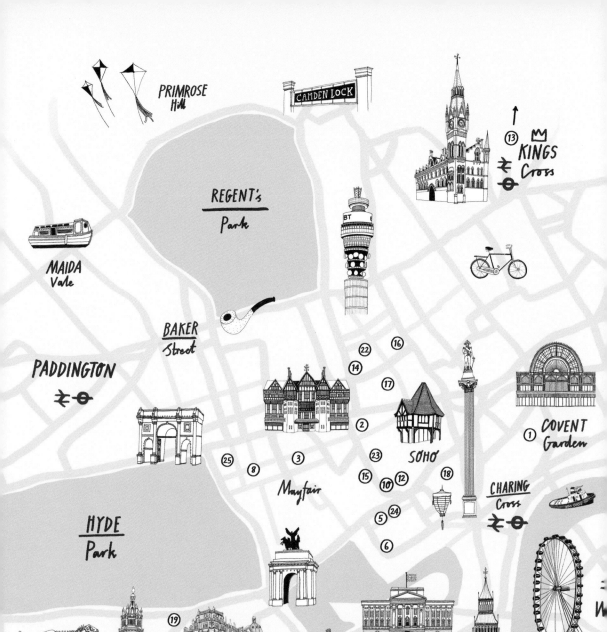

PRIMROSE Hill

CAMDEN LOCK

REGENT's Park

↑

13 ♔ KINGS Cross
⇄
⊖

MAIDA Vale

BT

BAKER Street

PADDINGTON
⇄ ⊖

22 16

14

17

2

COVENT Garden
1

25 3 23 SOHO

8 15 10 12 18

Mayfair

5 24 CHARING Cross
⇄ ⊖

6

HYDE Park

19

4

VICTORIA
⇄ ⊖

21

20

the
NGEL

the
BARBICAN

LIVERPOOL
Street

SPITALFIELD's

9

7

11

RIVER
THAMES

LONDON
Bridge

Wapping

Covent Garden is one of our favourite places in London – and features in other sections of this book. It's the ideal spot to eat and socialise during winter. You'll be pleased to know that over the festive period, Covent Garden transforms itself into a winter wonderland, complete with magical lights and a decoration extravaganza. This once included a huge reindeer towering over the piazza and a magical 'Winter Wood', a little forest made up of Christmas trees, decorated by the nearby boutiques and restaurants. The much-anticipated Christmas lights are usually switched on quite early on in the month of November by a celebrity. You can't miss – mostly due to its size – the giant 55-foot British-grown Christmas tree, which, glittering with more than 30,000 lights, is set up in the cobbled piazza. Also, all the adjacent streets around Seven Dials are adorned with an array of festive lights.

In the Apple Market, you'll see gigantic mistletoes hanging from the ceiling, so if you need an excuse to kiss your crush, you'll know where to take them, plus there are special craft stalls and goodies to be found. If you are looking for something to warm you up while you admire the festive decorations, there's plenty of mulled wine about, plus mince pies, too, perfect for when it's a bit nippy outside. Just follow the scent and you'll find the carts! And then there's the shopping...

+ INSIDER TIP

Covent Garden is a foodie paradise all year round. From Buns & Buns, with its gorgeous interiors and seriously great food, to the extravaganza of the all-day brasserie Balthazar, there is something for everyone. Petersham Nurseries' La Goccia and The Petersham, both nestling in Floral Court, always prepare a festive menu, whether it is an afternoon tea or a full feast.

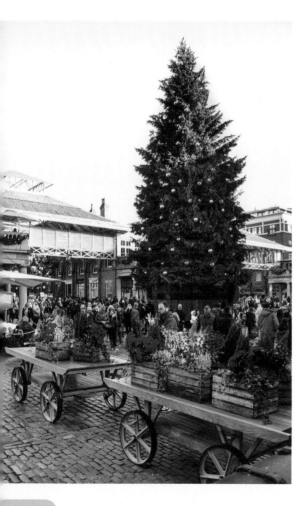

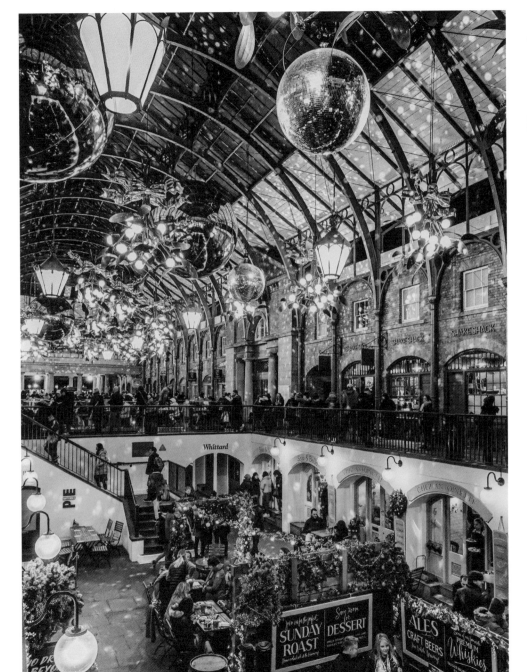

Liberty London

SHOP AT THE ONE OF THE OLDEST DEPARTMENT STORES IN LONDON

⊖ Oxford Circus

A much-beloved London destination all year round, Liberty London draws crowds from around the world at Christmas time. The dream of Arthur Lasenby Liberty, the department store opened its doors in Regent Street in 1875, its aim to bring luxury goods and fabrics from faraway places to the capital. A success, the flagship store, in Great Marlborough Street, opened in the 1920s, a time of Tudor revival, as seen in the store's iconic exterior. Nowadays, this luxury department store doesn't cease to impress people walking by with its majestic timbered black and white façade.

Liberty London's traditional Christmas shop, which opens as early as August, is an obligatory spot for your festive shopping. We can almost hear you thinking, August, are you mad? Well, we Londoners do love Christmas and as soon as summer is over, it's almost like we can already taste those mince pies and gingerbread biscuits. Plus, it is a great early opportunity for overseas tourists to buy little souvenirs to hang on their Christmas trees.

Expect exotic and unusual ornaments, bejewelled trinkets and over 1,000 bauble designs to choose from. We are sure you'll find something to impress even the most antitraditional of friends. Plus, Liberty likes to be extravagant with decorations, even on the inside of the store – a past creation was a giant floating velvet bonsai, running through all the floors. Not your typical Christmas tree, right?

If you feel like doing some non-festive shopping or buying a gift for yourself, then head to the ground floor for silk scarves with famous Liberty prints, browse their curated beauty section or simply get lost wandering around all six floors. We guarantee, you'll be charmed by the impressive wooden architecture.

+ INSIDER TIP

Head to the adjacent Carnaby Street for more Christmas lights and decorations, which, most of the time, are as funky and creative as Liberty's. Previous years have included a marine-theme, created from recycled materials and the lyrics to a famous Queen song. Even Mr Liberty himself would have been proud of this street as his vision was to create new trends and not to follow existing fashions.

W
I
N
T
E
R

Christmas Decorations in Mayfair

SHOP AT THE ONE OF THE OLDEST DEPARTMENT STORES IN LONDON

⊖ Bond Street, Green Park

When, in November, London is transformed into a wintery wonderland with festive decorations, giant Christmas trees and colourful Christmas lights, this means that winter has officially started in the capital. London is arguably the best city to spend the festive season in, and it gets better and better every year, with lots of different events, Christmas markets, ice rinks and beautifully decorated shop fronts.

One of the areas that goes above and beyond is Mayfair. If you're in London, chances are you'll pretty much already be in the Christmas spirit, but here you'll actually feel the magic. New Bond Street and Old Bond Street dress up in elegant Christmas lights, with the designer fashion brand stores and art galleries following their example. Our favourite is Cartier [1], which turns its flagship store into a giant gift box, with red bows and twinkling lights. Also lovely are Tiffany's [2], Louis Vuitton [3] and Ralph Lauren [4], but it's worth walking along both streets as there are new decorations every year. If you want to see something truly mesmerising, then you will want to head to Berkeley Square, where fancy member's club Annabel's [5] has been putting up a

Each Christmas, Annabel's installs a stunning tree in Berkeley Square.

BOND
Street

Grosvenor
SQUARE

⑧ 34 Mayfair

MAYFAIR

Berkeley
SQUARE

⑤

Annabel's

Louis VUITTON

③

Cartier

Cartier ① ④

②

⑨

Sexy FISH ⑥ ⑦

Royal Burlington
ARCADE ARCADE

GREEN PARK

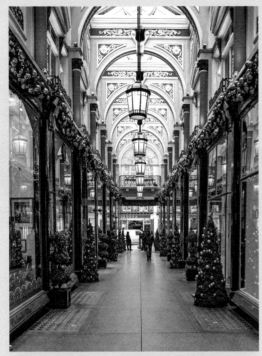

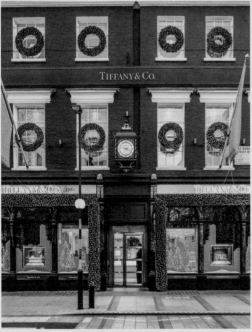

13-metre tall Christmas tree the past few years. They have been changing the design of the tree every year, so who knows what they will come up with next! The Royal Arcade [6] and Burlington Arcade [7] also turn into stunning, beautifully decorated Christmas passages, making you feel as if you're in a Christmas movie, and there are Christmas pop-ups and special events, too.

Timing is key to getting the best shot of Mayfair's decorations. If you want a people-free shot, your only option is to go first thing in the morning, but this won't work for the arcades as their gates are likely to be shut. If, instead, you want the photo that best captures the Christmas spirit, our recommendation would be to go just after sunset, as all the lights will be switched on and it will be nice and bright.

After visiting all these places, and spending way too much money on Christmas shopping, you may want to grab some food. We would recommend dropping by either 34 Mayfair [8], which likes decorating their restaurant with 16,000 Christmas baubles, or Sexy Fish [9], which always puts up a lovely festive display and, more importantly, serves mouth-watering food.

This page: The Royal Arcade. ***Bottom:*** *Tiffany's.*
Opposite: *Cartier decorates its Bond Street store with a giant bow.*

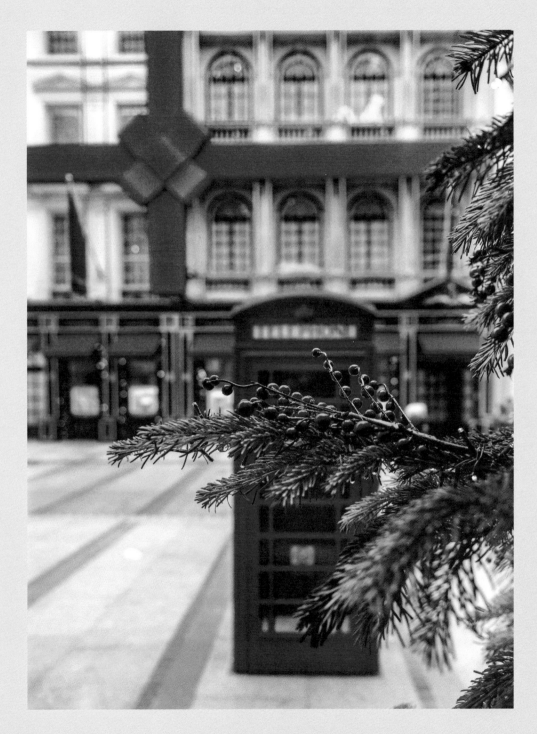

Ice Skating at the Natural History Museum

ICE SKATING IN THE MOST MAGICAL SETTING

⊖ South Kensington

The Natural History Museum is one of London's great tourist destinations and a world-famous museum. During winter though, it's exterior is transformed into an ice rink. You can't visit London during the festive period and not go ice skating there at least once! As soon as the days get chillier, ice rinks start popping up in the capital for the joy of Londoners and visitors, but this South Kensington ice rink is definitely one of the most scenic, with the iconic museum making for a glorious backdrop, not just for your pirouettes or comical falls, but for those Insta-moments, too.

Usually open from October to January, the open-air rink is set among twinkling fairy lights and a glittering Christmas tree. And, after all that skating, you'll probably fancy a much-deserved hot chocolate, so head to the alpine chalet-themed Café Bar for a winter warmer. Of course, a wander inside the museum is a must, too. Once you step inside, the museum's impressive architecture is bound to hold you spellbound. There are many rooms to get lost into, but we recommend checking out the volcano and earthquakes' gallery, where you'll find the famous earthquake simulator.

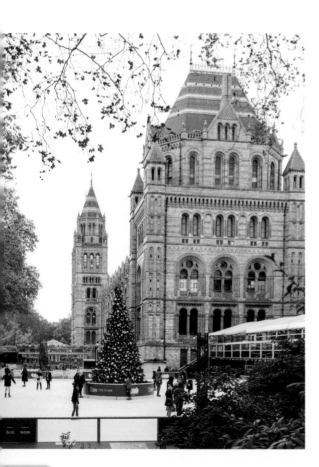

◎ INSTAGRAM TIP
〜〜〜〜〜

For the perfect picture, head to the rink during sunset time, when the lights are twinkling but there's still enough natural light for you to shoot. Our favourite angle is from above South Kensington's tube station on Exhibition Road.

Fortnum & Mason

FESTIVE AFTERNOON TEAS AND CHRISTMAS SHOPPING AT THIS LONDON INSTITUTION

⊖ Piccadilly Circus, Green Park

Fortnum & Mason is *the* Christmas department store of dreams, with its luxurious hampers, Christmas tea sets, mince pies and festive decorations. The store loves this time of the year so much that their Christmas shop is up and running in August, with preparations starting in July, while everyone else is still at the beach soaking up the sun. But it's in November when the magic really happens, as the trees go up, the Christmas tunes are switched on and the impressive staircase is full of decorations and fairy lights. Even the Grinch would find it hard to not be festive at Fortnums!

We have been there many times during Christmas, and we can definitely recommend stopping by, as even if you decide not to buy anything, it's an experience on its own. We personally love the iconic afternoon tea, the hot chocolate from The Parlour, the classy barber on the top floor and the festive treats from the famous food hall. Anything you decide to do here, it'll be worth it!

+ INSIDER TIP

Fortnum & Mason always goes that extra mile decorating its façade at Christmas, so you will want to capture it. The best way to do this is by standing on the opposite side of the road and waiting for a black cab or red double-decker bus to pass by. Early morning or night is the best as Christmas in this neck of the woods is busy!

W
I
N
T
E
R

Berry Bros. & Rudd

LONDON'S SMALLEST PUBLIC SQUARE, MULLED WINE AND ONE OF THE OLDEST BUSINESSES IN BRITAIN

⊖ Piccadilly Circus, Green Park

Berry Bros. & Rudd is a wine and spirit merchant in St James's, founded in 1698. It is one of the 10 oldest family-run companies in Britain and grew from being a small coffee shop to an internationally renowned business. We've been told that little has changed since this shop first opened at No. 3 St James's street and walking inside is like travelling back in time.

As well as over 5,000 different wines and spirits, some from the finest wine regions like Bordeaux, Burgundy and Piedmont, Berry Bros. & Rudd have their own selection of alcohol. We especially love No. 3 Gin, one of the best spirits we have tried in London and particularly perfect if you are a gin-based martini lover.

During Christmas, Berry Bros. & Rudd gets very festive by putting together a selection of mulled wines, fine sherries and some unique takes on Christmas classics. Most importantly though, they always set up a beautiful Christmas tree in Pickering Square, London's smallest public square and once a notorious venue for cockfighting and bear-baiting!

+ INSIDER TIP
~~~~~~~

*A visit here is always worth your time, even if you decide not to buy anything. However, if you fall in love with this place, just like we did, there are a number of tasting experiences, wine and spirits courses, and social events going on during the year, but especially during the festive period, so be sure to check out the website before heading to this historical shop.*

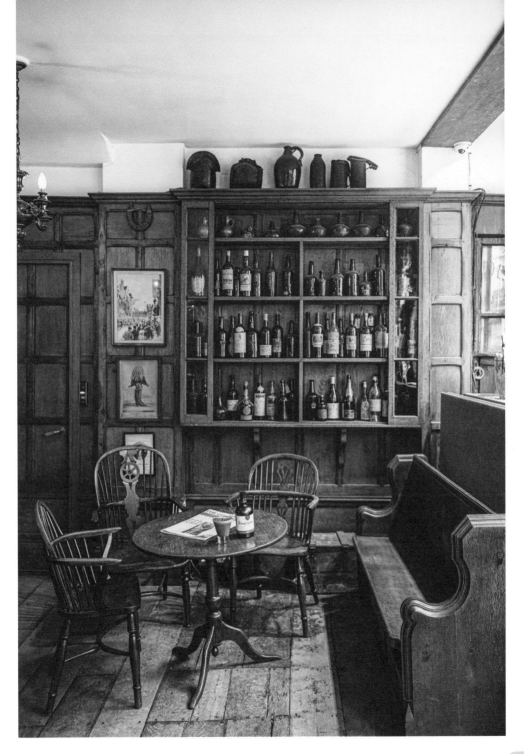

# Searcys at The Gherkin

CHAMPAGNE BREAKFAST AT THE TOP OF THE GHERKIN

⊖ Aldgate, Liverpool Street

If you are looking for a festive place to have breakfast, then you definitely won't want to miss out on this one. Set on Level 40, at the very top of The Gherkin, Searcys Bar offers unparalleled 360 degree views over London. Head there for the Champagne breakfast, usually in action from November, which will make you drool. Feast on perfectly cooked eggs benedict and indulgent berry and cream waffles, among other treats. All, of course, paired with Laurent-Perrier. If this is not the perfect way to start your day, then we definitely can't be friends. You'll love the magical early morning light and the feeling of being at the very top of one of our favourite – and most recognisable – London skyscrapers. Sounds, so lush, right? To add a bit of sparkle to your breakfast is the show-stopping Laurent-Perrier-inspired Christmas tree. This is lit up in the evenings, making some sky-high pre-dinner cocktails a must.

🄾 INSTAGRAM TIP

*To have the place almost to yourself, go at around 10am on a weekday and request a table by the glass windows overlooking some of London's greatest landmarks – Tower Bridge, the City and St Paul's.*

WINTER

# Christmas Afternoon Tea at Claridge's Hotels

### INDULGENT AFTERNOON TEA WITH A FESTIVE FEEL AND CHRISTMAS CAROLS

⊖ Bond Street

## INSTAGRAM TIP

*After afternoon tea, head to the end of the hotel's lobby, by the Grand Staircase, and you'll find one of the most striking Christmas trees in the city. This fashion-inspired festive landmark is a magnet for visitors and locals alike, who come to marvel at its design. Christian Louboutin, Diane von Furstenberg and Karl Lagerfeld are just some of the recent illustrious fashion icons to have contributed to one of the most awaited reveals of the year.*

If you are looking for a gift for a special person or are simply searching for a Christmassy afternoon tea, then Claridge's is the place to go for something with a touch of luxury. This five-star hotel in Mayfair is a London staple all year round and a historic, glamorous Art Deco landmark. Since its beginnings in the 1850s, Claridge's has been praised by everyone, from movie stars to statesmen and fashion designers alike, impressed by its impeccable service and fine dining. And we completely agree.

Partake of Christmas afternoon tea and you can expect all things merry and joyous, from flowing champagne to festive pastries and spiced Christmas puddings – all in a beautifully decorated mirrored room called the Foyer. The music playing from the grand piano makes the atmosphere truly magical and you can even hear some live carols at Christmas. It really doesn't get more festive than that! The tea includes a choice of 24 fine teas from around the world, delicate finger sandwiches and freshly baked scones – we personally like to add a glass of Laurent-Perrier to make our experience even more perfect. There's no better way to sprinkle a little joy on your winter afternoon in the countdown towards Christmas!

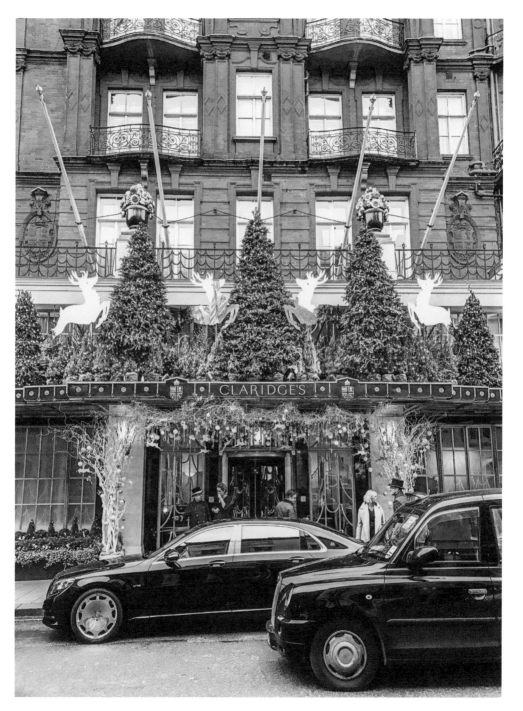

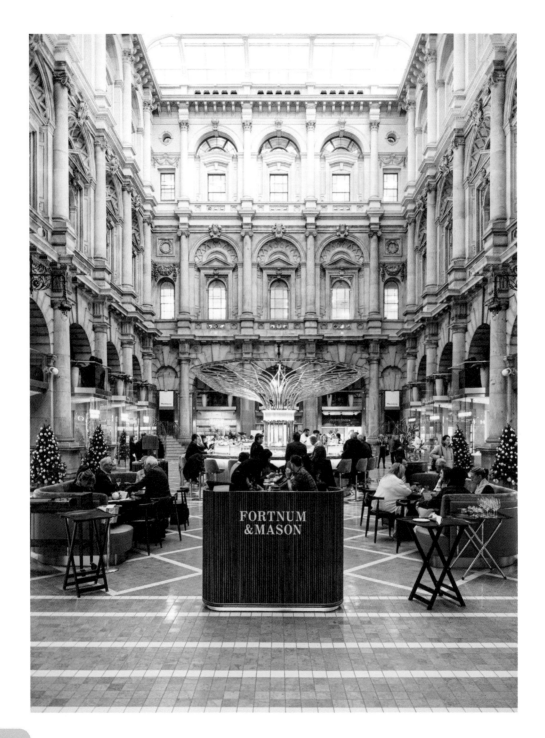

# The Royal Exchange

## LUXURY SHOPPING AND FINE DINING IN AN HISTORICAL CITY BUILDING

⊖ Bank

+ INSIDER TIP

〰〰〰〰〰

*A hidden gem in the Exchange is Cutter & Squidge, an 100% all natural bakery where everything is made from scratch and, wherever possible, using British ingredients or those sourced from British producers. Their passion is creating delicious new products and reinventing time-honoured classics in a healthy fashion.*

The Royal Exchange is, for many, an escape from the hustle and bustle of the busy City of London. Founded by English merchant and financier, Sir Thomas Gresham, this historical building was originally opened in 1571 as a commercial market place. Completely destroyed by the 1666 Great Fire of London, it was reopened three years later on a different site by the Lord Mayor. It was destroyed by fire again in the 1830s and the current building, the result of an architectural competition won by Sir William Tite, is based on the original structure, but with an impressive eight-column Pantheon-inspired entrance. It was opened by Queen Victoria in 1844.

The inside of this impressive building features 24 paintings showcasing the history of trade in Britain. The Royal Exchange stopped being a centre of commerce at the beginning of World War II and has housed many different enterprises since. It was remodelled in 2001 to become what it is today, a retail centre with shops, cafés and restaurants.

Although it is a go-to destination all year round, it is particularly lovely to visit during the Christmas festivities. Every year, a luxury-themed Christmas tree is set up outside (usually sponsored by one of the brands within the Exchange) getting everyone in the right mood for some great Christmas shopping. The Exchange houses a number of luxury shops, making it a great destination to buy something special, but the highlight of the Exchange has to be the Fortnum & Mason bar and restaurant.

The famous department store has given life to one of the prettiest restaurants in town, serving champagne and French cuisine in an atmosphere that takes you back in time. So, if you are feeling exhausted after a tiring day of Christmas shopping, a stop here for dinner and drinks is definitely recommended.

# Brasserie Zédel

### CELEBRATE EPIPHANY AND DON'T FORGET YOUR CROWN!

⊖ Piccadilly Circus

One of the many magical things about London is how many restaurants seem like nothing special from the outside and then are spectacular on the inside. This happens especially in central London, where in between all the infamous food chains you often find some real gems. That is exactly the case with Brasserie Zédel, a Parisian-style brasserie well-hidden beneath the streets of Piccadilly. The entrance to the restaurant is on a side road, through a café and down an extremely elegant staircase, at the bottom of which you'll find a lobby full of retro ticket booths, Art Deco, glittering chandeliers and paintings. Off of the lobby there is a bar, theatre and cabaret venue and, in the main room, the restaurant. The latter is magnificent, high-ceilinged, spacious, filled with marble pillars and has an ambiance that will make you feel as if you have just been teleported to Paris.

Our favourite day of the year to visit Brasserie Zédel is Epiphany, when they offer Londoners a free three-course meal if you show up wearing a crown! It's a really fun evening that can get booked up pretty quickly (as you can imagine), so be tardy and you'll miss out!

+ INSIDER TIP

*Brasserie Zédel is quite reasonably priced considering its location and the quality of the food. Located in theatreland, it's especially great if you are heading to one of the many nearby venues for the evening. It will definitely get you in the mood!*

# Leadenhall Market

## HARRY POTTER, CHEESE AND WINE BY THE CHRISTMAS TREE

⊖ Monument, Bank

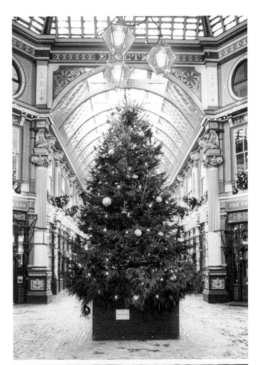

Leadenhall Market, in the heart of the City of London, just loves getting all dressed up for Christmas. Every year, a 20-foot tree, right in the centre, keeps the shops and restaurants company for a few weeks.

Going to this fourteenth-century covered market during the festivities will make you feel as you have just entered a scene in a Harry Potter movie. Why is that? Because it's exactly where they filmed the area of London between the Leaky Cauldron and Dragon Alley in *Harry Potter and the Philosopher's Stone*. This is also where, in Charles Dickens' iconic *A Christmas Carol*, when Scrooge famously asks a passing boy to buy the biggest and fattest turkey to send the Cratchetts, the boy would have gone.

Our favourite restaurant is Cheese at the Leadenhall, a speciality independent cheesemonger that has great wine-pairing options. In winter, they provide blankets, so you can sit outside sipping wine and eating cheese right by the Christmas tree. How festive!

### ⊙ INSTAGRAM TIP

*Leadenhall Market is in the middle of London's financial district, so if you want to enjoy a pint surrounded by business people in suits, go at lunchtime or after 6pm. For something more relaxed, it's best to avoid those hours.*

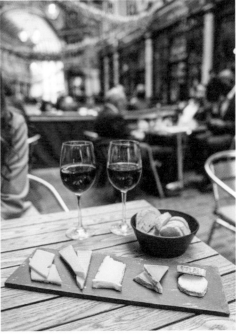

## Hotel Café Royal

MAGICAL VIEWS OVER REGENT
STREET AND AN OPULENT
AFTERNOON TEA

⊖ Piccadilly Circus

Hotel Café Royal is undoubtedly the place to stay in London during Christmas. Located in a majestic historical building, the site of the famous Café Royal, right on the corner between Regent Street and Piccadilly, this hotel is both in the middle of the action but also secluded and quiet in its own magical way. You'll love it during this time of year, as it's basically surrounded by all the most beautiful Christmas decorations in the city! Imagine seeing the lights being switched on from your own room, how magical would that be?

And speaking about rooms, don't forget to pick one with a view. The most beautiful suites include the Grand Regent Suite, which has a magnificent view over St James's and Piccadilly Circus (which of course will be all dressed up for Christmas); the oak-panelled Tudor Suite, which includes an original Tudor fireplace taken from an old English manor; and the top-floor Dome Penthouse suite is truly a work of art and even has its own private rooftop terrace. All the marble bathtubs come directly from Carrara in Italy, and legend has it that they were shaped right there in the rooms by their own in-house marble specialist, so as not to risk cracking the marble.

Needless to say, the dining options at the Hotel Café Royal are top-notch. The Laurent on the first floor is not only beautiful but has some of the best sushi we have ever had and it is also open on Sundays for bottomless brunch with live music. If you are not convinced just yet, you need to know about the huge spa and Akasha Holistic Wellbeing Centre in the hotel's basement. Featuring a tranquil 18-metre pool, hammam, sauna, hot tub and gym, it will take a lot of courage to get out and brave the cold of London after this.

+ INSIDER TIP
〰〰〰〰

*For incredible, inventive desserts, matched with a wide selection of Champagne, visit Cakes & Bubbles at street level. Led by 'World's Best Pastry Chef', Albert Adrià, you cannot miss the Cheese Cake, it's not like any cheesecake we've had before, and we still dream about it. The Golden Egg Flan is also Instagrammable and so delicious!*

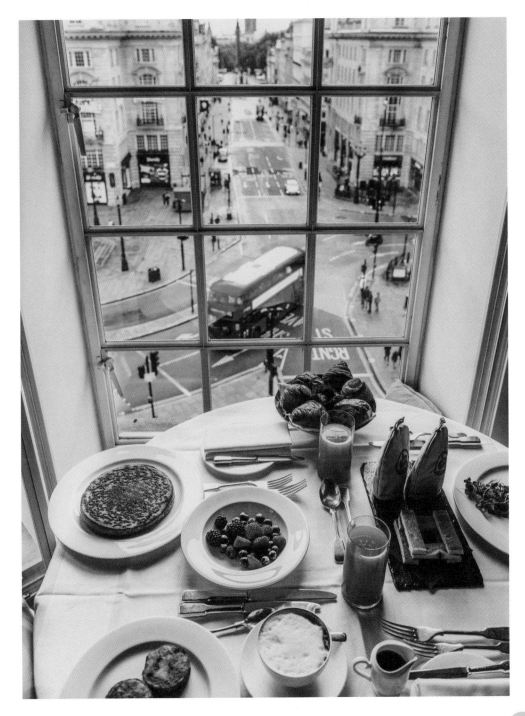

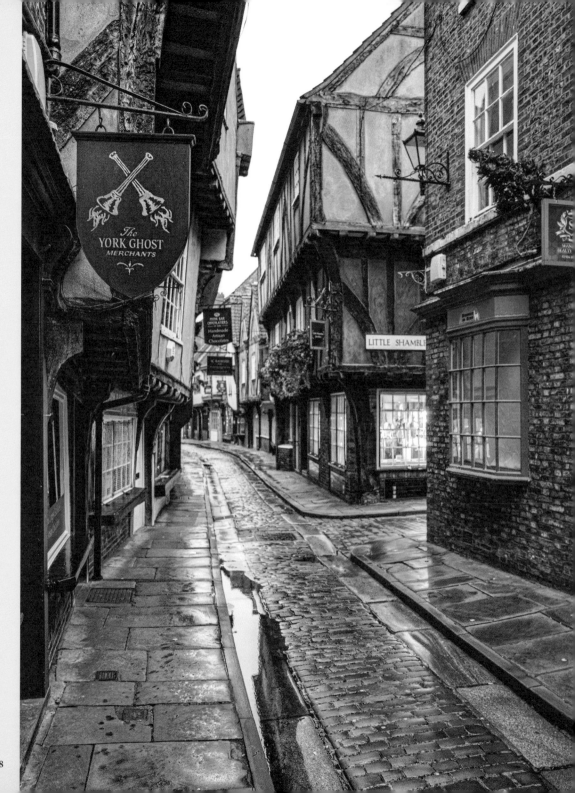

# A Day Trip to York

WANDER AROUND THE SHAMBLES OF THIS SPOOKY MEDIEVAL TOWN

≥ Kings Cross → York

York, in the north of England, is one of those cities that everyone raves about. It is bursting with history, medieval buildings and, according to some, it's the most haunted city in Europe, with its streets plagued by ghouls and ghosts. Less than two hours away from London by train, you can pretty much explore it in a day. York is more like a big village and is pretty much surrounded by medieval walls, which you can spend time walking along, if you choose.

The first place you'll want to visit is York Minster, a towering Gothic cathedral, with stunning interiors that date back to the 1200s. It's one of the largest Gothic cathedrals in northern Europe. Here you'll also find the best view over the city. All you need to do is climb the 275 steps leading to the top of the central tower! Five minutes' walk from the Minster is the Roman Bath, the remains of an ancient bath house in the cellar of a pub! There's even a small museum.

Great views can be seen from Clifford Tower, the oldest part of York Castle, and what you must do in York is wander around the ancient streets of the city, the most famous being the Shambles, which dates back to Roman times. This narrow street is considered to be the oldest – and possibly most haunted – shopping street in Europe and it can get pretty crowded, so we'd recommend going early if you can, before the tourists invade.

There are many places to dine in York. Betty's is an institution and perfect for afternoon tea. Or you may want to try out one of city's many old pubs, such as

The Golden Fleece, reported to be the most haunted pub in Europe. For something a little more modern, we suggest The Botanist for their good food and cocktails served in quirky glasses.

*Opposite:* The cobbled shopping street, the Shambles. **This page:** Betty's is renowned for its iconic, classic British afternoon tea.

# Treehouse Hotel

## STAY IN YOUR OWN NEST IN THE CLOUDS

⊖ Oxford Circus

Arriving directly from the US, the stylish Treehouse is one of the latest additions to London's hotel scene. A bit nostalgic and very playful, Treehouse is perched high on Langham Place, minutes away from buzzing Oxford Street. The rooms start from the ninth floor, so rest assured, they all have beautiful views over the city's skyline. The big bay windows let in plenty of light and all the little fun touches scattered around the room will surprise you and make you feel like you are in your childhood treehouse of dreams. We stayed in the Studio Suite, which is cosy and colourful and has a lovely window nook, perfect for curling up with a hot drink and a book, while admiring wintery London just beneath you. On the same level as the reception, on the 15th floor, is Madera, their in-house, elevated Mexican restaurant, which offers some of the best shrimp tacos we have ever had. Their signature entrées, served on hot lava stones, are also unmissable. As well as having plenty of vegan and vegetarian options, the restaurant is also truly gorgeous – think loads of plants, hanging bulbs and floor-to-ceiling windows. Grab a table with a view and enjoy a spicy margarita as you look down onto London! On the upper floor there is a rooftop bar on the upper floor called The Nest, which provides wraparound city views, great cocktails and truly beautiful decor; it's a millennial heaven. There's even an outdoor terrace for those long-off summer days, or just to have a look-see at the dazzling views.

◎ INSTAGRAM TIP
〰〰〰〰

*If you are looking to capture The Nest empty, make sure to go at opening time, 12pm, as it gets really busy really quickly.*

# Momo

### YOUR WINTER ESCAPE
### TO MARRAKECH

⊖ Piccadilly Circus, Oxford Circus

If you have a thing for Moroccan food and decor, like us, then you will go crazy for Momo. This effortlessly cool, stylish and trendy restaurant on Heddon Street, off Regent Street, will make you feel as if you're spending a night in Marrakech. Perfect if you want to escape the wintry cold and mentally travel somewhere warm.

Momo has been running for more than twenty years and gives you the real Mediterranean experience from top to bottom, from seductive tunes from the desert to fabulous staff (the type of service you should expect from fine dining) and a truly great ambiance. The food is full of layered flavours, with tasty starters and tagines, paired with Moroccan wines. However, the main highlight of the menu for us is the couscous, the best one we have ever tried by far.

If that is not enough, Momo launched Kwant Bar, tucked away in their basement, which, with its live music and cocktails, can be considered a destination in its own right. The bartenders – led by the incredible Erik Lorincz – are super skilful and will go the extra mile to make you happy, even making cocktails based on your tastes that are not on the menu.

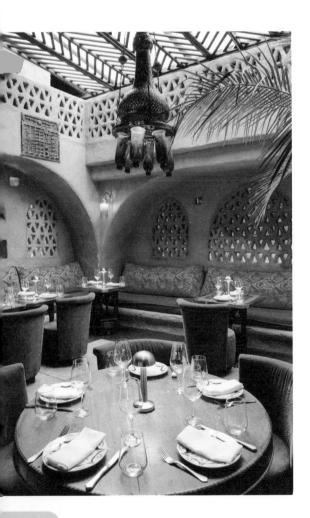

+ INSIDER TIP
〰〰〰〰〰

*If you are bored with traditional afternoon tea and want to try something a little different, then you must try the one at Momo. It is Moroccan-inspired, with miniature traditional Maghrebi treats and sandwiches with a spiced twist and a great selection of infused mint teas, as well as the more usual kind. Also, have we mentioned that all the pastries are made in-house?*

Looking for a cute little place to spend some time in between shopping, eating and drinking? Pollock's Toy Museum might be just the right place for you, especially if you want something that looks great in a picture, as the hand-painted façade is highly Instagrammable. Located on a corner of Fitzrovia, this small museum is a collection of toys and dolls that mostly date back to the Victorian era, although there is a clay mouse toy that goes back to Egyptian times. The museum's collection has been built up over the years by purchases and donations from family and friends and they are displayed for passion rather than for profit. In the room at the front, there is a quirky toy shop that sells tin toys, wooden miniature vehicles and board games. We know the exhibits may be a little creepy for some – especially if you have a doll phobia – but we think it's definitely worth a visit!

# Pollock's Toy Museum

## CREEPY OR CUTE? JUDGE FOR YOURSELF!

⊖ Tottenham Court Road, Warren Street

○ INSTAGRAM TIP
〰〰〰〰〰

*Nearby is the Insta-heaven eatery, Dalloway Terrace, which every season puts on a show. During the winter months, it is a wonderland of pinecones, snowy branches, sheepskin rugs and water bottles, making you feel like you're in a luxury alpine resort. Head there for some winter warmers – real toddys and mulled wine – or a cosy breakfast early in the day, if you are aiming for a restaurant-empty Instagram shot.*

# Arros QD

## THE BEST PAELLA IN THE CITY TO PRETEND YOU'RE IN SPAIN

Tottenham Court Road, Oxford Circus

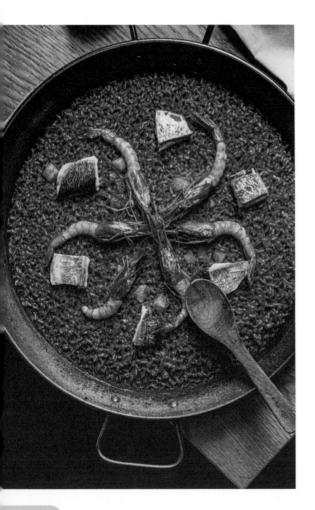

For a reminder of summer during wintertime you can't beat Arros QD, a stylish Valencian restaurant located in the midst of Fitzrovia. The chef, Quique Dacosta, is a master in twisting traditional paellas and Mediterranean dishes into something modern and trendy. The menu is inspired by the ancient trade routes from Africa and Asia into Spain. What we like the most, apart from the interiors and well, the food, are the six-metre long woodfire stoves at the entrance. We love watching the chefs cooking our paella, working their magic in the most theatrical of ways. The menu changes during the year, so expect to find seasonal dishes and ingredients. If you need a little help in navigating the menu, we particularly love the cheese stones with parmesan, manchego cream and cocoa butter, which do look like shiny pebbles, but taste like little drops of heaven, plus the mouth-watering monkfish and spicy miso skewers. From their *chapas*, which are smaller oven-cooked rectangular rice dishes, we recommend the black squid-ink rice, calamari, artichokes, dill and aioli, while from the *socarrat*, which are crispy caramelised thin layers of rice toasted on the pan's bottom, we recommend the shrimp and saffron aioli.

The giant cookies with vanilla ice cream dessert is worthy of a boomerang, so get your spoon ready and get cracking!

+ INSIDER TIP

*Flatter dishes look great in flat lays so paella makes for the perfect prop in your picture. Add a few elements to the composition, such as your hand holding a spoon for a 'human touch' or a few smaller dishes to make the picture complete. If you find a table with a nice texture, such as marble or a wooden surface, even better.*

# Chinatown

CELEBRATE CHINESE NEW YEAR AND EAT YOUR WAY THROUGH
THE STREETS

⊖ Leicester Square, Piccadilly Circus

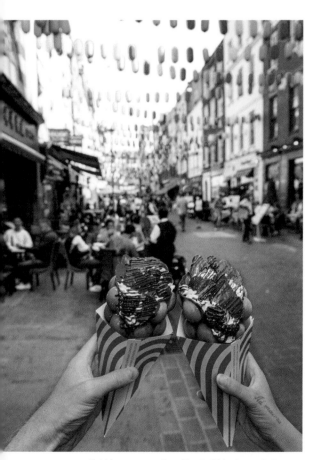

*Bubble wraps are the ultimate Chinatown photo prop.*

Located near busy Leicester Square and Soho, Chinatown has been an iconic area in London since the 1970s. Each year, millions of people walk through this neighbourhood, taking pictures of the Chinese gates, dragons and lanterns and searching for the best restaurant in which to eat some incredible Asian food. The event that most people look forward to in Chinatown is definitely Chinese New Year. The date changes every year, depending on the lunar cycle, and the festival celebrating it lasts around two weeks, so you will need to check beforehand when the festivities commence. Be sure to drop by, as you will find colourful parades, spectacular stage performances, dragon dances and much more.

Eating Asian food is a big part of the Chinatown experience, so you will want to try the best. Something that we have found particularly challenging during our first meanders in Chinatown is distinguishing a good restaurant from a bad one, as some may not be particularly pretty from the outside but serve outstanding food and cocktails. Our favourite restaurants are Plum Valley with its authentic dim sum made fresh every day and Orient. For bao buns head to Bun House,

WINTER

while for cocktails and delicious food head to Itchy Buns, Hovarda London, Experimental Cocktail Club and Opium. If you have a sweet tooth, there is a little street that we like to call 'Dessert Alley' where you can find some delicious Asian treats, such as at Kova Patisserie, with their famed fish-shaped waffle, and Tsujiri Matcha House for all things matcha.

INSTAGRAM TIP

*Want to take the ultimate Chinatown picture? Then head to Bubble Wrap and order two of their pretty waffles, then go to the street and shoot a photo with one of the beautiful Chinese gates in the background. That's probably easier with a smartphone than with a camera, unless you have a third person with you taking the picture.*

*Top:* Kova Patisserie. *Bottom:* Bun House.

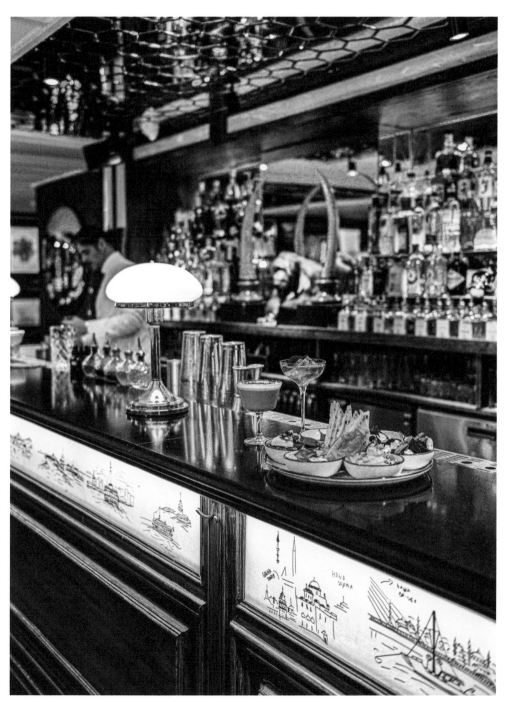

Head to Hovarda for Aegean-inspired food and cocktails.

# Sette

## TRY THE SCARPETTA SPAGHETTI, YOU WON'T REGRET IT!

⊖ Knightsbridge

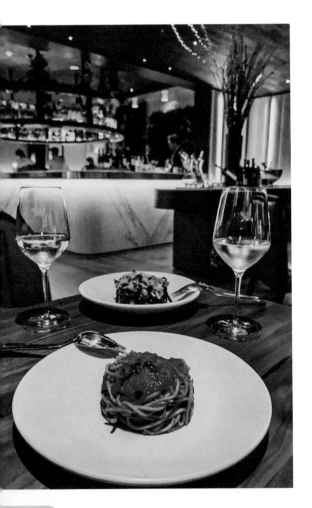

We know that shopping in Knightsbridge can be very tiring and stressful sometimes, especially when it involves battling your way through the crowded isles of Harrods. This is when Sette comes into play, an Italian restaurant that's part of New York City's Scarpetta restaurant family and is located on the ground floor of the Bvlgari Hotel, although it also has an entrance on Knightsbridge Green.

This restaurant has a very sophisticated and pleasant atmosphere, with a great bar for some pre-meal drinks. We are Italian so we are very fussy about our pasta, and means that too often we have left Italian restaurants disappointed, as something's always not quite right. Sette, however, has become our go-to place if we want to treat ourselves to perfectly cooked fresh pasta (a lot of which is not available in other Italian restaurants) like *agnolotti* and *scialatielli*. Also, the ingredients are sourced from Italy and often seasonal, so special menus are often available, depending on when you book.

But what really stands out for us about Sette is that the simplest dish on the menu is also the tastiest one. The 'Scarpetta' spaghetti, or simply spaghetti with tomato and basil, is to die for, and even though we love trying different things each time we go, this is always among the dishes that we order. The braised octopus with marble potatoes is also worth a try, and the Gianduiotto dessert of *gianduja* chocolate and stracciatella gelato is also a must.

+ INSIDER TIP

*Fancy a 'New York night' after some delicious Italian food? Well you don't need to go far, as downstairs, underneath Sette, is Nolita, a social space providing a vibrant atmosphere in which to enjoy cocktails, live music and DJs.*

# Angel Comedy Club

## FOR SOME GOOD OLD BRITISH HUMOUR

⊖ Angel

Nestled in the pretty streets of Islington, the Angel Comedy Club is the perfect place to stay warm on a cold winter night, or simply head there if you feel like you need a laugh. This comedy club has a free show every day of the week and promotes new talent, not just the big names. They have two venues, the Camden Head and the Bill Murray. The latter is also a pub, running comedy courses and community projects.

If you are looking to go, they generally have improv shows on Mondays, solo shows on Tuesdays, new acts on Wednesdays, Thursdays and Sundays, and on Fridays and Saturdays comics perform their most popular sets. It's always good to check their website beforehand as things may change, and it's also good to arrive early as it gets quite packed.

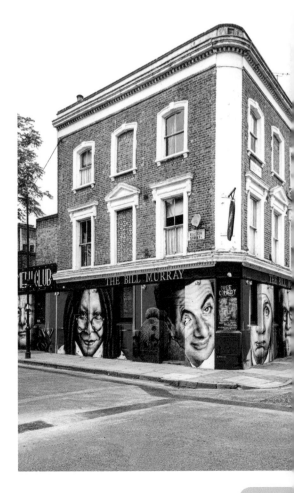

+ INSIDER TIP
〰〰〰〰〰

*Angel is full of great pubs, so why not make it a night and head to one of them after the show? Our favourites are The Old Queen's Head, where you can sit next to the fireplace, and The Alpaca.*

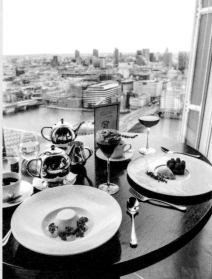

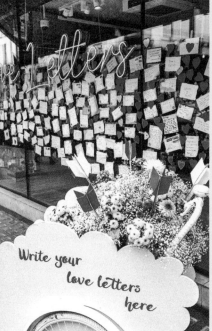

*This page, clockwise from left:* The unique pink dining room at Sketch. Dinner with a view at Aqua Shard. Visit Hedonism Wines to see their valentines window display. **Opposite:** Maddox Gallery are famous for their huge floral installations.

# Valentine's Day

> Valentine's Day is a tricky one. It's that day of the year that people pretend they don't care about but – let's be real – they actually do.

London is a great place to spend the most romantic day of the year, as there are plenty of intimate restaurants to go to with your partner or simply for a friend date. As with every festivity, London puts on a show with its floral displays and special menus, which usually involve a lot of chocolate and special 'aphrodisiac' dishes. One of our favourites is Peggy Porschen, which has an Insta-famous store in Belgravia (where people actually queue to take pictures) and a slightly less busy one on King's Road in Chelsea. They always put up a stunning Valentine's Day display from the beginning of February and have the cutest cupcakes. If instead, you are setting up a romantic dinner at home and fancy buying a bottle of wine, head to Hedonism Wines in Mayfair as they always come up with the most creative Valentine's displays (and have wines from all over the world). While you are in Mayfair, you will not want to miss Maddox Gallery, who usually set up the biggest floral display of them all. In terms of restaurants, The Ivy takes Valentine's Day very seriously so it's worth checking out what they have on. Sketch is also great for a date night, or you could try one of the restaurants in The Shard, our favourite is Aqua Shard.

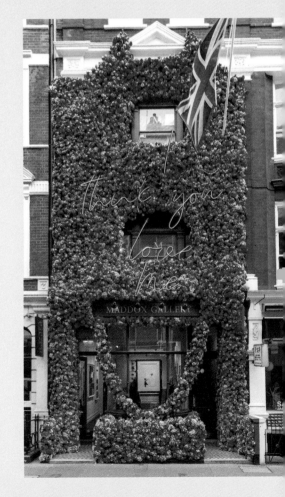

# Attendant Fitzrovia

SPECIALITY COFFEE IN A DISUSED
VICTORIAN UNDERGROUND LOO

⊖ Oxford Circus, Goodge Street

Hidden in an abandoned Victorian toilet in Foley Street, this tiny espresso bar is definitely one of London's trendiest little spots. Both outside and inside, the decor is utterly adorable and needless to say, just perfect for Instagrammers. It has two other sister locations in Shoreditch and Clerkenwell, but we think they're not half as pretty as the one in Fitzrovia. A two-year project, this abandoned loo, originating from the 1890s and left derelict for more than fifty years, was restored to great splendour. Inside, the original Doulton & Co. porcelain urinals have been lovingly transformed into a peculiar, but striking green and white seating area, in line with the original Victorian floor tiles. Okay, okay, we can hear you asking, but is the coffee actually good? Absolutely! Attendant pull their very own espresso blend directly from the Attendant Roastery, making it one of London's top speciality coffee places. Their brunch and breakfasts are pretty too, using seasonal produce. Better get a brioche bun with that coffee.

+ INSIDER TIP
〰〰〰〰〰

*Attendant is just a five-minute walk from Oxford Street, so it's the perfect place to have a coffee break in-between shopping.*

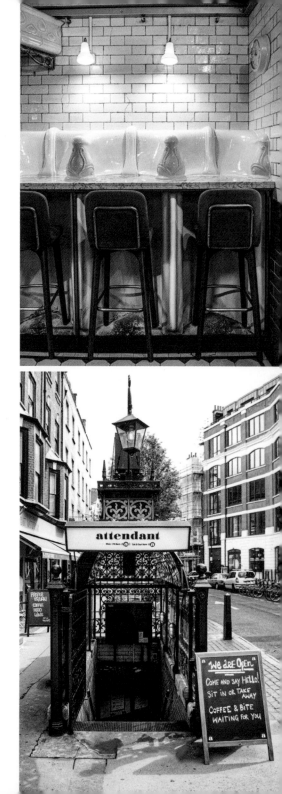

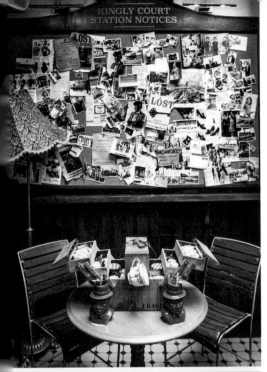

RT 717

# Cahoots London

STEP BACK IN TIME IN THIS UNIQUE
LONDON SPEAKEASY

⊖ Piccadilly Circus, Oxford Circus

Set just behind Carnaby Street, in the heart of Soho,
Cahoots consists of three diverse and unique spaces
– Underground on Kingly Court, and Ticket Hall and
Control Room on Kingly Street. Located at ground
level, and easily accessed via both streets, is Cahoots
Ticket Hall. This space, was once was a busy station
for commuters on-the-go in the 1940s, until it was
abandoned, and now it offers everything from cocktails
to afternoon teas and brunches. With all the feel of
postwar London, old peeling posters on walls and
vintage advertisements in the toilets (which are adorable
by the way), we could spend hours admiring all the
details. Worth mentioning are the cocktails, which are
not only great, but are served in vintage-looking food
tins, sometimes teacups and other wacky glasses.
We love the 'Tea for Scoundrels', which is not your
typical afternoon tea! Served in wooden crates with
lots of secret compartments, you're given clues and
have to solve them to unlock your tea – and the final
compartment is filled with all the ingredients for a make-
it-yourself cocktail. Just ask for ice and you'll be set!

+ INSIDER TIP
〰〰〰〰〰〰

*Located directly opposite The Ticket Hall is Cahoots
Underground. Simply follow the signs and you'll discover
yourself in a disused underground train station. The best
feature is definitely the life-sized vintage tube carriage,
complete with seats and handrails.*

W
I
N
T
E
R

# Maison Assouline

## A STYLISH TEA BREAK IN CENTRAL LONDON

⊖ Piccadilly Circus, Green Park

Maison Assouline is unique. It is a luxury library with antique objects, great coffee and sophisticated furniture, right in the heart of St James's, London. And no one really knows about it.

When we are looking for a little spot to switch off after a photoshoot or back-to-back meetings in central London, this is our go-to place. The coffee shop is all about style, and so are its books, making it a beautiful place for a creative person to pass time in. There are lots of limited editions and travel books worthy of buying just to flick through their beautiful images. And even the coffee – served on the prettiest trays – is an experience in itself. After every visit, we just feel like telling the whole world about it, but then we always decide to keep it our little secret so that we can always find a table. Guess the secret is out now!

+ INSIDER TIP
〰〰〰〰〰

*If you feel really inspired by the artistic books in Maison Assouline, less than five-minutes' walk away is the prestigious Royal Academy of Arts, which we are sure will keep you warm and entertained with its many exhibitions and displays.*

# Mercato Mayfair

### FOODIE DESTINATION IN A DECONSECRATED CHURCH

⊖ Bond Street, Marble Arch

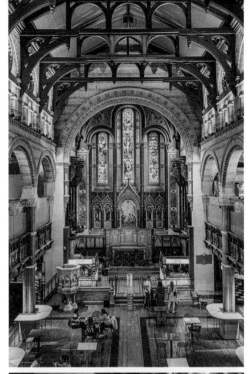

Another creation from the guys behind Mercato Metropolitano (see page 66), is this brilliant food market in the most unusual of settings. Mercato Mayfair is nestled in a deconsecrated west London church, which, after years of private use, has been restored to its original splendour. Music to our ears! The food on offer is outstanding and almost everything is fresh, artisanal and sustainably sourced. Between two levels of food stalls and bars you'll be spoilt for choice as to what to pick. There is even a secret rooftop terrace and a vaulted crypt in the basement, which hosts a wine cellar, a cheese and charcuterie section and a microbrewery. Some of our favourite stalls are the seafood and cocktail-oriented Cha Cha Mayfair, Steamy & Co for bao buns and dumplings, and Fresco for amazing pizza. There are two dedicated bars if you get thirsty, so are you ready to take your G&T at the altar?

⊙ INSTAGRAM TIP
〜〜〜〜〜

*Head to the gallery on the upper floor for the perfect angle overlooking the altar and the colourful glass windows at the back. The more centred you position yourself, the straighter your photo will be, so spend a few seconds finding a picture perfect spot.*

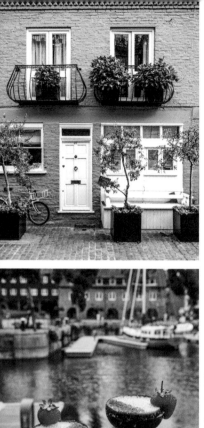

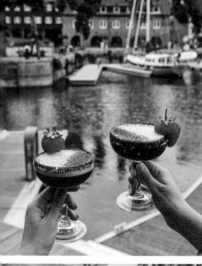

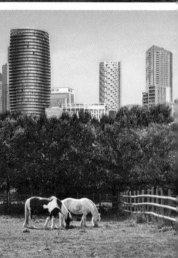

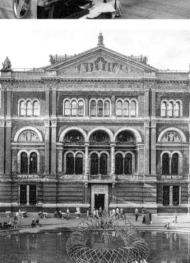

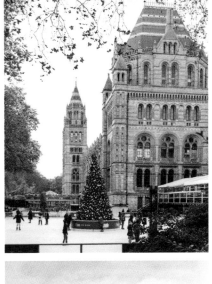
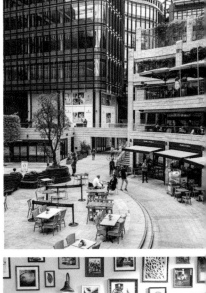
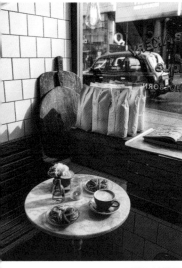
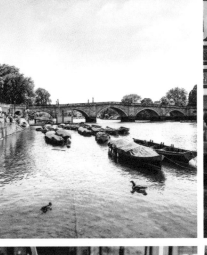

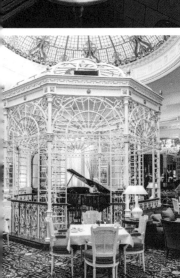
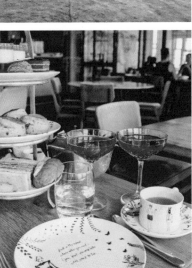

# Acknowledgements

Creating our first book has been a real journey and we couldn't have done it without:

**Our Followers** – Thank you to every single person that clicked on that little 'follow' blue button over the years, making @prettylittlelondon what it is now. Without your daily love, support and engagement from all over the world this wouldn't be possible.

**London's Content Creators** – Thank you to our Instagram friends and colleagues, for being brilliant, inspiring and of great help since the very beginning.

**Friends** – Thank you for all the lockdown phone chats, voice notes, continuous support, love and excitement for this book even when far apart. You know who you are.

**Family** – Thank you to all our family and in particular our parents Antonio and Joy, Maria Paola and Gabriele and Nonna Ilva. Thank you for supporting us and always encouraging us to chase our dreams.

**Publishing Team** – Alice, Charlotte, Cerys, Rachel and everyone at Quarto. Thank you so much for asking us to create something so beautiful together, trusting our vision and guiding us every step of the way.

Finally, thank you to everyone who is reading this now, in buying this book you have helped us making this lifelong dream and milestone achievement a reality. We sincerely hope it will inspire you to explore this wonderful city in all its beauty and diversity.

First published in 2021 by Frances Lincoln Publishing
an imprint of The Quarto Group.
The Old Brewery, 6 Blundell Street
London, N7 9BH,
United Kingdom
T (0)20 7700 6700
www.QuartoKnows.com

Text and photography © 2021 Sara Santini and Andrea Di Filippo

Every effort has been made to trace the copyright holders of material quoted in this book. If application is made in writing to the publisher, any omissions will be included in future editions.

A catalogue record for this book is available from the British Library.

ISBN  978-0-7112-5761-0

Ebook ISBN 978-0-7112-5762-7

10 9 8 7 6 5 4 3 2

Design by Rachel Cross
Illustrations by Zoe More O'Ferrall

Printed in China

MIX
Paper from
responsible sources
FSC® C016973